How To Draw

SUPERNATURAL BEINGS

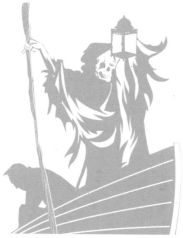

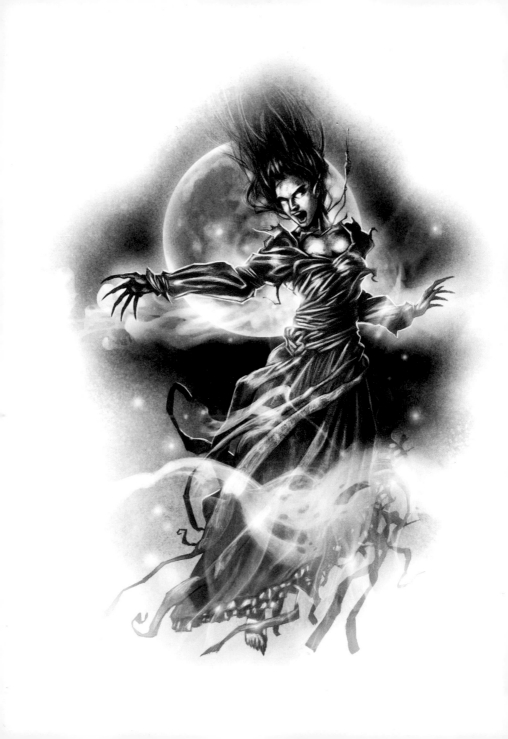

How To Draw

SUPERNATURAL BEINGS

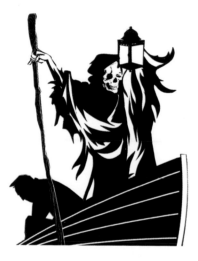

Andy Fish

CHARTWELL
BOOKS, INC.

This edition published in 2011 by
Chartwell Books, Inc.
A division of Book Sales, Inc.
276 Fifth Avenue Suite 206
New York, New York 10001
USA

ISBN-10: 0-7858-2717-X
ISBN-13: 978-0-7858-2717-7
QTT.HDSN

A Quintet book
Copyright © Quintet Publishing Limited
All rights reserved.

This book was conceived, designed, and produced by
Quintet Publishing Limited
The Old Brewery
6 Blundell Street
London N7 9BH
United Kingdom

Project Editor: *Martha Burley*
Editorial Assistant: *Holly Willsher*
Designer: *Rehabdesign*
Art Editors: *Jane Laurie and Zoë White*
Art Director: *Michael Charles*
Managing Editor: *Donna Gregory*
Publisher: *James Tavendale*

Printed in China by Midas Printing International Ltd.

Contents

INTRODUCTION: DEPICTING SUPERNATURAL CREATURES

I llustrating supernatural beings presents nearly limitless possibilities for artists of all skill levels. Whether opting for a classic depiction of an ancient creature of folklore, or going for an all-new take on an innovative discovery, the fantasy artist is presented with unique challenges and opportunities.

The successful supernatural artist will allow their imagination to go wild to create distinctive and exciting pieces of art. No matter what your skill level, from beginner to expert, this book will help you to improve your skills in depicting supernatural creatures. All that is required of you is a sincere effort and the ambition to succeed.

Working discipline

Discipline is an important element in becoming a better artist. A great old college art professor once claimed that every artist has 2,000 bad drawings in them, and it takes a great deal of discipline to get to drawing number 2,001. Creating a reasonable work schedule to devote to your art will aid you in hitting drawing number 2,001.

Some artists keep a calendar handy that they can refer to, and use it to schedule time for themselves to just sit and draw. A little bit here and there adds up to a whole lot of art.

Observe real life

Even though you're working in a highly imaginative and creative genre, the best artist understands that the ability to render real-life objects well goes a long way toward making your work professional. Don't skimp on the details, and spend at least one hour a day with a sketchbook on a visit to a public

place where you can draw interesting people, places, and things—all of this will lead to a better final piece of art. The desire to get better is something all artists should feel, no matter where they are in their careers.

An artist can find inspiration in many places, including magazines, newspapers, or movies—it's a matter of taking the initial idea and stretching it.

Composition

Composition is something that should always be considered. With all fantasy art, trying to work in a narrative structure is always better, so rather than having your characters standing around in their environment, try to imagine what a particular part of their day would involve, then show this. For example, if you wanted to depict the Native American flying head you could simply draw a horrible creature in the night sky (see below, left). However, the illustration would be so much better if it included horrified villagers running in every direction as the head swoops down toward them—providing a context in which to appreciate what this creature is all about (see below, center). The illustration could be further improved if the composition were set the moment the flying head swoops down on the villagers, who are gathered around the communal bonfire, allowing for dramatic lighting and a sense that the villagers are actually living, because they are doing something rather than standing around waiting to be attacked (see below, right).

Left Don't just settle for your first attempt when you are working out your composition. Think about how you can improve it by giving it a sense of scale and environment. In this example, our "Floating Head" creature illustration becomes more interesting with the addition of screaming victims and a different angle.

Another way to optimize your illustration is to use the rule of journalism in thinking through your composition. To ensure that you produce a depiction

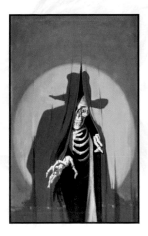

Above George Rozen's "The Creeping Death," from *The Shadow Magazine*'s cover, 1933.

that stands out from the average, ask yourself the following questions:

> • *Who are the principle characters in your illustration?*
> • *What are the actions they are involved in?*
> • *Where is the action happening?*
> • *When: What is the time of day, the time period, and the setting?*
> • *Why are the characters together?*

Roots and styles of supernatural art

Supernatural art has a long tradition stretching back to the woodblock prints of the Middle Ages, through Japanese silk tapestries, and into the Victorian age of Europe with depictions of all manner of bizarre creatures. However, the real explosion of supernatural art has to be with the American pulp magazines of the 1930s, in which artists such as George Rozen took masterful understandings of painting techniques and applied them to this newfound art form with unprecedented skill.

Right Illustration by Shigeru Mizuki from the *Yokai Encyclopedia*, 1981.

Typical supernatural beings

Our fascination with supernatural beings goes back to the beginnings of mankind, when ancient man would draw pictures of wild beasts on the walls of his cave home. Often the idea of a creature lurking in the darkness was created for our own protection, and parents would tell their children stories about supernatural creatures in an attempt to keep them safe. The *qallupilluit*, for example, are creatures from Inuit mythology that lived in the cracks of ice near the ocean edge. Children were warned that if they got too close to the cracks, the *qallupilluit* would rise up and grab them. For the artist there are, of course, very many supernatural beings to draw inspiration from; some that exist in the myths and folklore of various cultures, and others created by modern popular culture.

Left The *qallupilluit* were creatures that rose up out of the cracks of the ice to snatch children to a horrible fate in Inuit mythology. How they are depicted is up to the artist's imagination.

Supernatural sea

Sailors played a big part in spreading the myth of supernatural creatures on the open sea, telling tales of monsters from far-off lands made them very popular as storytellers. It's not difficult to imagine the reaction they might have had when first encountering a great white shark or a giant squid and mistake them for horrible sea monsters.

The living dead

The dead that still walk the earth take a number of forms. Although vampires and vampiric creatures, living off the blood or the life-energy of other beings, have been apparent in mythology for well over a thousand years, it was really in southeastern Europe in the early eighteenth century that the modern idea of the vampire was born. The publication of Bram Stoker's classic vampire novel *Dracula* in 1897 cemented the creature as possibly the king of all supernatural creatures, and vampires continue to reign in popularity today.

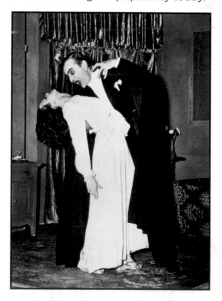

The western African belief in voodoo gave birth to the idea of the zombie, and in 1929 W. B. Seabrook published the book *The Magic Island*, which explored the discovery of several voodoo cults and their propensity to resurrect the dead, sometimes to be used as slaves, and at other times to enact revenge on their enemies. The modern take on zombies is often that they are mindless creatures whose only motivation seems to be to eat the brains of the living.

Right *Dracula*, starring Bela Lugosi and Helen Chandler was directed by Tod Browning, and released in 1931.

A ghoul is thought to live in cemeteries and burial grounds in both Arabian and North American myth—sharing the same attributes Islamic folklore gives it, the ghoul is thought to feed on human bodies.

Spirits

Demons have existed in virtually all civilizations, and are thought to be the embodiment of evil spirits visiting our world from the underworld, wreaking havoc on the lives of normal humans.

The Middle East is home to the *afrit*, from Arabic mythology, which is thought to be a ghost-like figure made of fire.

A banshee is a ghost from Irish and Scottish folklore, usually a female spirit that lets out a high-pitched shriek to warn of someone's impending death. She is often depicted in long white robes with stringy, fair, wispy hair.

Myths

The troll comes from Norse mythology, and was believed to be a giant elf-like creature that often took its pleasure from inflicting pain and misery onto any humans it encountered from its home underground in hills or caves. The males are thought to be dimwitted, while the female versions are especially conniving, and therefore even more dangerous.

Above The banshee is often represented as a woman who is a messenger from the Otherworld. Find out how to recreate this illustration on pages 118–23.

From English folklore comes the infamous Spring-heeled Jack, a bizarre little man-like creature known for leaping around the rooftops of London, sometimes in his top hat and tails.

The bogeyman might be the most famous of all myths, often appearing to frighten misbehaving children who would refuse to go to sleep. While every culture has its own version of the bogeyman, few have given him any kind of a distinguishing look.

Animal-like beings

Tied closely to the idea of the vampire, the werewolf is a lycanthrope, a shape-shifter that can transform from man to wolf, usually during a full moon, after which it preys on its fellow man. Some southeastern European villages

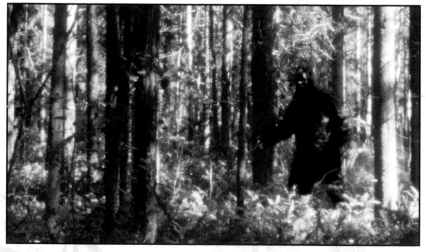

Above Purported shots of Bigfoot are repeatedly realeased into the public eye. The most famous film of Bigfoot was taken by the hunting team of Patterson-Gimlin in the woods of California in 1967.

and African tribes still fully believe in the idea of the werewolf as a thing of reality. Fairy tales were often based on supernatural myth, and many have surmised that the wolf that devours grandma in the story of Little Red Riding Hood was himself a werewolf.

Creatures living in the wilds take various forms. The Yeti in the Himalayas is rumored to be 6–9ft (2–3m) tall and resemble a great albino ape, while his cousin the sasquatch (also known as Bigfoot) supposedly continues to leave his giant footprints in the wilds of North America.

In the United States the Jersey Devil is thought to roam the woods of New Jersey, often striking out at cars traveling down lonely roads late at night. Described as looking like a small horse or dog with bat-like wings, it often strikes from the darkness, scaring its intended victims with its piercing scream. Mexico has the legendary *chupacabra*, also known as the Mexican goat-sucker, a vampiric, four-legged creature that resembles a dog and is prone to attacking livestock.

Above A sketch of the terrifying Jersey Devil.

The Story of the Flying Head

The sasquatch owes much of its renown to the myths of the Native Americans, who also believed in the equally fascinating Flying Head, a creature thought so terrifying that to look at it would cause death in its victims.

The story claims that the Flying Head was plaguing a village every month on the full moon. Village elders recognized that they had women and children to protect, and so forged a plan to lay in wait on the next lunar occurrence. The bravest of the village men would take their places in treetops and in low foxholes dug specifically to prepare for the oncoming creature's attack.

The women in the village objected to the plan, thinking it fruitless to attempt to defeat such a horrific and obviously otherworldly creature with simple hunting tools. However, the men dismissed the women as lacking the knowledge needed when it came to battle and, on the next full moon, sent them to prepare a delicious feast that they could enjoy once their mission was successfully completed. The women gathered together and began preparing the meal. However, without the men's knowledge, they also forged a plan should the men fail.

When the creature attacked the men were ready, however, they failed to anticipate the abject horror of the creature's very appearance, and many fell dead at the mere sight of it. Others ran for the safety of the village, realizing that their weapons were as useless as bows and arrows against lightning.

As the men ran and hid inside the village houses, one group of women flung open their cottage door, at which point both the light spilling out in the darkness and the aroma of the delicious meal successfully lured the Flying Head to their doorstep. Pretending not to notice the ominous creature filling the doorway, the women put on a performance, acting as if the glowing hot rocks they used to cook their meals were the base of the feast, and feigning their delight as they purported to eat the rocks.

Ravenously hungry and unable to take the delicious scent any longer, the Flying Head burst in and swallowed all of the bright glowing rocks without chewing. Within seconds it shrieked and flew out into the night, never to be seen again.

As an artist, try to envision an illustration that comes to your mind after reading this frightening Native American myth.

Man's creations

When Mary Shelley penned the classic *Frankenstein: or The Modern Prometheus*, she gave us one of the most prominent supernatural creatures of all time—the monster made through science and black magic. The golem shares many of the same physical attributes as the Frankenstein monster, except that he is completely made of clay and, like the legend of the native zombie, he owes his allegiance to the master who conjured him.

Real horror

Reality can even give birth to myth. London's Jack the Ripper was very real; a serial killer murdering at least five women in the fall of 1888. The fact that he was never caught, and his apparent incredulous ability to avoid capture despite Scotland Yard's ever-tightening net, has created the possibility of a supernatural aspect to Jack's work. Artists of the day often conjectured on his appearance, and one of the most famous illustrations in the annals of crime is by illustrator John Tenniel from London's *Punch* magazine. The Ripper became the symbol for the blight and sorrow of London's Whitechapel district during this time; more than just a criminal.

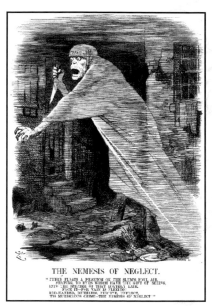

THE NEMESIS OF NEGLECT.

Above Published in 1888, the "Nemesis of Neglect" cartoon poem about Jack the Ripper was reproduced in *Punch*.

Death

There is one supernatural figure that all cultures recognize, and he is perhaps the most fearsome of them all. His coming heralds one's time for departure to the Netherworld. He is of course the Grim Reaper, the embodiment of death itself—although this creature should probably not be referred to as a "he," since many cultures think of this hooded entity as a female.

Interestingly, certain cultures consider Death to be a welcome figure, one that comes to the sick and weary and leads them to a better place. This "nice-guy" image is reflected in Greek mythology, where Death is depicted as a kindly old man, almost Santa Claus-ish in appearance. However, this kindly figure would escort the newly departed to Charon, a skeletal figure clad in black robes and a hood, who would escort the new souls down the River of Purgatory—a place between life and death—to begin their journey to the afterlife. It's likely that today's depiction of the Reaper owes much to that of Charon.

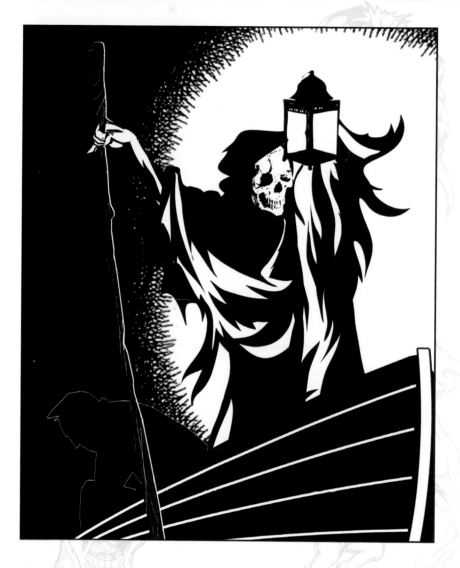

Above A modern artistic representation of Charon, escorting new souls down the River of Purgatory.

CHAPTER 1
TOOLS, TECHNIQUES, AND BASIC SKILLS

This chapter is the place to start before you create your fantastical creatures and scenes. This basic foundation course recommends the best tools and takes you through the elements of drawing.

TRADITIONAL TOOLS

When it comes to drawing equipment, such as pencils, brushes, pens, and papers, your mantra should always be to buy the best you can afford.

Pencils and erasers

There are a variety of pencils the artist can choose from. Good-quality pencils glue the lead throughout the pencil so there is no interior breakage. Mechanical pencils are another option. These never require sharpening and can be fitted with any grade of lead. An eraser is bound to come in useful when working with pencils, and the soft white plastic type does not damage your paper like the older pink ones do.

Above and left Some of the essential equipment you will need to get sketching.

9H	8H	7H	6H	5H	4H	3H	2H	H	HB	B	2B	3B	4B	5B	6B	7B	8B	9B

Hardest lead Softest lead

Pencil grades

Pencils are graded based on the hardness or softness of the lead. "H" stands for hard while "B" stands for black, since a softer lead usually produces a darker (blacker) line. The degrees are measured sequentially, so a 4B lead is softer than a 2B lead, which is softer than a B. The same is true at the other end of the spectrum, with a 4H being harder than a 2H, which is harder than an H, and so on. A hard lead produces a lighter line.

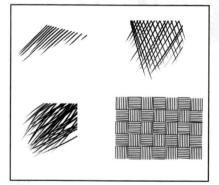

Pencil techniques

When you begin sketching, try holding the pencil sidewise, more like you would a paintbrush if you were starting an underpainting. This method lets you work loosely and keeps your work fluid.

Hatching is a pencil technique that uses lines to create tonal values. There are four main types: hatching, which uses single parallel lines; cross-hatching, which uses crossed hatch lines; free-hatching, which features very loose lines; and patch-hatching, which features lines used in patchwork-like pieces.

Above Hatching with your pencils can achieve numerous effects.

Below Holding your pencil sidewise helps give a fluidity to your work.

Hatching at work

To experiment with putting hatching techniques to work, start with a basic drawing of a werewolf.

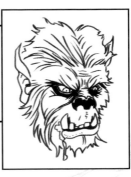

Step 1: Draw lines in one direction, then go over the same area in the other direction. As you spread the lines apart you start to create a dense, gray effect.

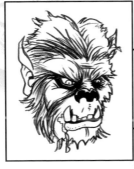

Step 2: Choose one side of the head to start your crossed hatch lines, in this case working from the left-hand side over to the right.

Step 3: Overlapping lines create the cross-hatch effect. Additional hatching lines add texture across the face. You can also try blending hatch lines with a stump, a tool used specifically for this task.

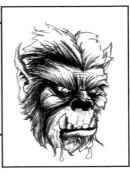

TIP

Remember that good lighting is essential. There is no better light than natural light; however, when you are working inside, a solid desk lamp with an extendable arm can help you direct the light where you need it.

Papers and drawing boards

There are more kinds of paper than there are stars in the heavens, or at least that's what Shakespeare would have told us if he ran an art supply store. Paper is judged based on its thickness—referred to as "ply"—its texture, and how it reacts to various art supplies.

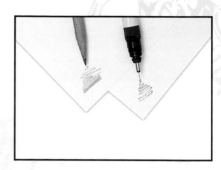

Above Bristol paper takes both pen and pencil well.

Left Illustration board is a thicker option and is useful for when you wish to scan an item into the computer so you can work digitally.

Bristol board, or Bristol paper, is available in plies from the very thin 1-ply to very thick 5-ply, in rough or smooth textures. Illustration board is also an option. This is extremely thick, almost the equivalent of 14-ply Bristol board.

A good sketchbook, for sketches, planning, and experimentation, is also an important tool.

Inks, pens, and brushes

Inks are available in many colors; however, a good black ink is essential in any artist's toolbox. Types of ink include water-based varieties that dry quickly and can be blended with water; waterproof ink, which is more permanent, in richer blacks, and of archival quality; and pigment ink, which sits on top of the paper and is very slow drying.

The application of ink to your illustrations can be achieved with a variety of tools. The tip of a quill pen is dipped into the ink, and a variety of tip styles are available. The pen should be drawn toward you to give the best line. A brush is another option, and will give a smooth line.

Colored inks
Water-based inks are available in a wide range of colors.

Brush sizes
You'll want a few different-sized brushes, some for working small details and others for filling in large areas of black on the illustration.

India ink
Waterproof black India ink comes in a variety of bottle sizes.

Inking techniques

Inking requires a great deal of experimentation—only by trying out different methods can you discover techniques (some of them quite unconventional) that will create amazing results in showing texture and shines.

Ink can be used to fill in your large black areas and shadows. Pens are great for fine detailing too—and they come in a wide variety of sizes from .005 all the way up to .10.

There are also pens that have a brush tip, called brush pens—and these combine the comfort of a pen with the great line of a brush. With practice they can be a valuable addition to your art supplies.

For effect, beautiful line, and speed—you cannot beat a brush for applying inks.

Before brushing ink onto paper, wipe the excess ink off your brush onto the lip of the bottle and try dragging the brush along the paper. Try using a very light and delicate line, then a heavier and darker line.

TIPS FOR BRUSH AND INK CARE

When you dip your brush into your ink bottle make sure that the bristles of the brush never touch the bottom of the bottle. The ink sediment there will clog up your brush. Never get ink onto the metal part of your brush head because that will oversaturate the bristles and cause them to wear out. Cleaning your brush properly is also vital.

Inking project

Step 1: Begin with the pencil stage.

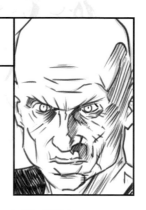

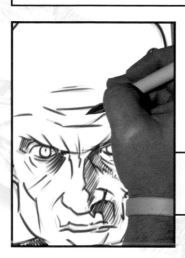

Step 2: Start by using your quill to outline the drawing lines.

TIP:

A cotton swab can give you some beautiful "dry brush" effects.

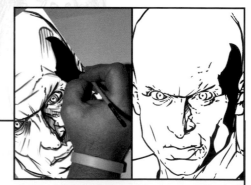

Step 3: Continue working until all your line work is done. The images look like something you'd find in a coloring book—now we're going to add textures, tones, and shadows.

Step 4: There are a variety of tools you can use besides just brushes and pens for putting down ink. A chopstick can put down some great "energy" dots.

TIP

Spend time in art supply stores, since they often have samples and demonstrations of new and existing products for you to experiment with. Don't be afraid to try new things.

Step 5: You can even sharpen a wooden chopstick with a pencil sharpener and dip it in ink to get finer dot tones.

LIQUID FRISKET

Liquid frisket is a valuable tool for masking areas of the illustration that you don't want to ink. The process of using it is fairly simple: shake the bottle up, and pour a small amount into a cup. Using a new clean brush, apply it as you would ink—only working in the areas you want to remain white. Once the ink has dried you can peel off the dried frisket, which works as a mask for the ink.

Basic drawing skills and styles

A strong understanding of drawing skills is important for any artist. People, animals, objects, and, of course, supernatural beings are made up of shapes, and it is these shapes that the artist needs to recognize and reproduce.

The human(ish) head

Drawing the human(ish) head is easy once you understand the basic rules of proportion.

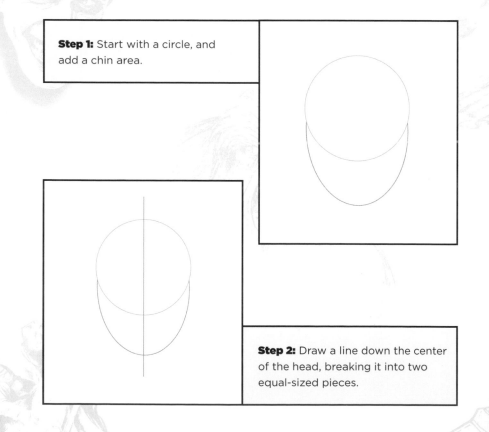

Step 1: Start with a circle, and add a chin area.

Step 2: Draw a line down the center of the head, breaking it into two equal-sized pieces.

Step 3: Draw a line halfway down the head, breaking it into quarters. Draw another line halfway between the bottom of the face (chin) and the eye line. This is where the nose will be.

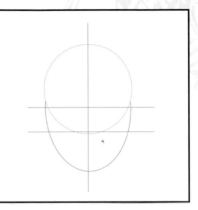

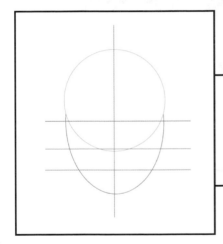

Step 4: About halfway between this new nose line and the chin is where the mouth will fall, so draw another line there. It's amazing how symmetrical the face is.

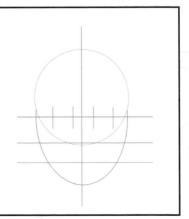

Step 5: Working from the vertical center line out, draw four hash marks along the eye line, evenly spaced apart.

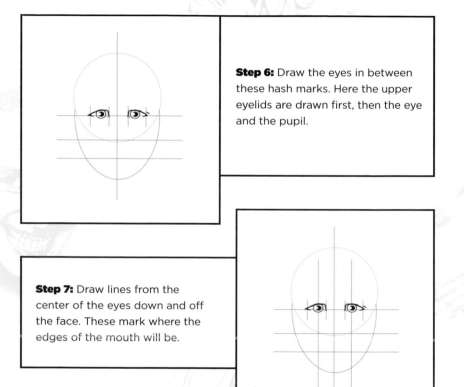

Step 6: Draw the eyes in between these hash marks. Here the upper eyelids are drawn first, then the eye and the pupil.

Step 7: Draw lines from the center of the eyes down and off the face. These mark where the edges of the mouth will be.

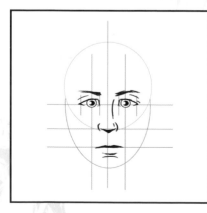

Step 8: Draw in the nose, mouth, and eyebrows. Eyebrows are always thicker toward the center of the face, and they narrow as they extend out.

Step 9: Finish off the head with some hair. Start toward the bottom and fan the hair out, keeping the top part light so it looks shiny and clean.

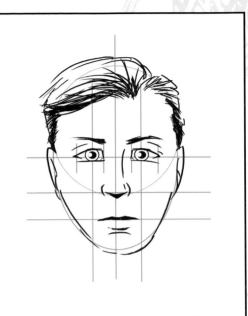

Turning heads

Once you understand how to draw the face from the front using proportional lines, you can then take this same concept and use it to draw a three-quarter view. Notice how, by simply "turning" the center lines of the face and allowing for the contours of the head, you are able to effectively draw a head turned at an angle. It's simply a matter of placing in the features using the proportional dimension lines as before.

The figure

Although this works on a simplistic level, the artist needs to recognize how fluid the human figure is if they are going to draw anything with drama or impact. From the side it's easy to understand the simple rules you need to follow to keep the figure from looking too stiff or unnatural.

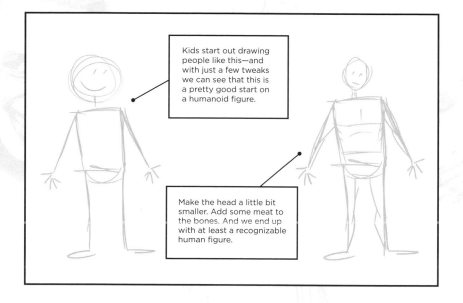

Kids start out drawing people like this—and with just a few tweaks we can see that this is a pretty good start on a humanoid figure.

Make the head a little bit smaller. Add some meat to the bones. And we end up with at least a recognizable human figure.

Above

The figures above look much too stiff, like he's guarding Buckingham Palace. In reality a figure stands much more naturally. See steps (opposite page 33) on how to achieve a more natural stance. Note the curved "S" of the spine, which results in the rib cage having a slight tilt back.

TIP

Practice drawing stick figures. Try to draw quick gestures of figures involved in different activities. By working with only basic stick figures you'll soon understand the subtle movements and poses that the body naturally makes, without getting too wrapped up in details.

Step 1: Draw a loose S line—the human figure doesn't stand stiff and straight—and add a circle at the top to represent where the skull will be.

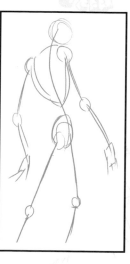

Step 2: Put in circles for the shoulders and hips, then add in arms and legs. Note that by keeping this posture loose the figure appears to be in motion.

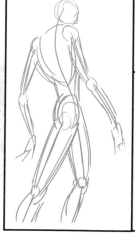

Step 3: Build up some "meat" and muscle on the bones to give the figure some bulk. Use circles for the shoulders, hips, knees, elbows, wrists, and any other joints on your figure, then cylinders for the arms and legs. As you study anatomy for reference you'll start to understand how these shapes can be manipulated to suggest muscle.

Exaggerated humanoid

Here is an example of how you might draw a more exaggerated, "cartoony" figure.

Step 1: Start with the basic shapes that make up the figure. Exaggerate proportions a little to give this figure a lot of upper-body bulk.

Step 2: Refine those shapes a little more and add detail to the overall design of the figure— here the muscle forms and the face are tightened up.

Step 3: Go over the drawing with a darker pencil to finalize the line choices.

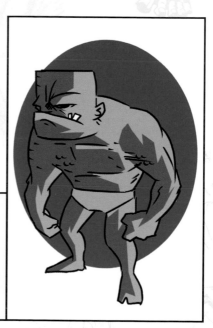

Step 4: The final step is to use reference material (see pages 70–3) to create a sense of texture and add detail to the drawing.

TIP

Figure-drawing sessions are available for artists of all levels in most large cities and around local colleges. See if there is one near you and make a plan to attend so that you can improve your basic figure drawing. If there are none nearby, grab a sketchbook and find a quiet spot in your local coffee shop or library and just draw people—these locations are especially good because here people tend to sit relatively still for a good length of time.

Proportion

It's important to understand proportion when trying to depict the human figure. Let's look at this illustration of the human figure by Leonardo Da Vinci.

A "normal"-sized person is about seven heads tall, as demonstrated by the red lines.

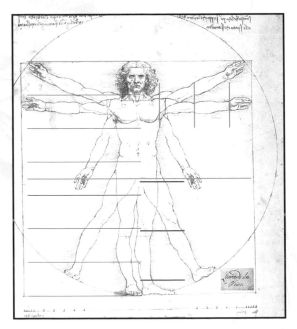

Left In figure drawing, the basic unit of measurement is the "head." This handy unit of measurement has long been used by artists to establish the proportions of the human figure.

The green lines show us that the upper arm and lower arm bones are essentially the same size (the elbow is the halfway point for the total arm). The blue line demonstrates the halfway point in the figure, which falls at about crotch level. When the arms are at their sides the fingers fall about mid-thigh or just past this blue center line. The purple lines in the illustration reveal that the upper leg and the lower leg bones are also essentially the same size.

You should note that both these bones are longer than the arm bones, and that the legs account for half of the height of a human figure.

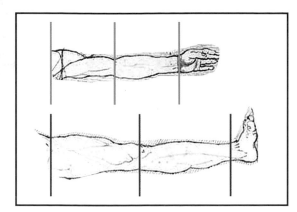

Left Use guidelines to divide into sections, this will make sure you work to the correct proportions.

Breaking the figure down into basic shapes might make this easier to see. Using simple geometric designs gives us a chance to see the basic shapes used to make the figure.

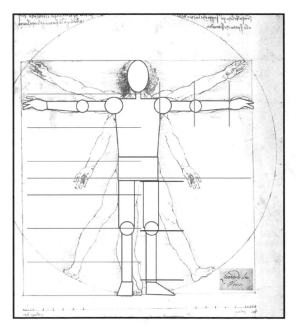

Right Using basic geometric shapes makes it much easier to draw the human figure with the correct proportions.

Foreshortening

By using shapes it also becomes easier to handle more advanced techniques such as foreshortening. The ability to foreshorten is imperative for giving your work a dynamic look.

Let's walk through the process:

A. Look at the shapes we use to make up an arm. There are circles for the shoulder, elbow, and wrist. These "ball joints" help us with keeping the proportions straight on the body as we draw it. In between these joints we use cylinders to represent the upper arm and forearm, and then give a kind of loose shape for the hand.

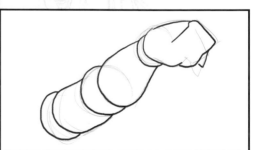

B. Let's look a little closer at a cylinder—when it's laid flat it appears flat, but if we raise it up toward the viewer it looks more like the illustration, right.

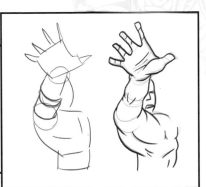

C. If we take that same method and turn the arm toward the viewer even more, the cylinders become foreshortened giving us the illustration, right.

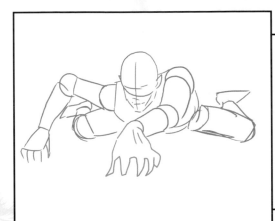

D. The entire figure works in the same way. Understanding the way that cylinder shapes interact allows us to pose the figure in a foreshortened manner.

E. Using this theory we can then create virtually any pose; this opens up an amazing array of possible action positions.

Hands

Hands are an element of figure illustration that many artists struggle with—but there are several methods of illustrating hands that are effective.

Step 1: Start with a slightly narrow square shape.

Step 2: From the bottom right-hand corner draw a hooked line; this will be the thumb.

Step 3: Draw straight lines up from each side of the square—the one on the right slightly longer than the one on the left—these will be the index and pinky fingers.

Step 4: Now draw two more straight lines up between the ones you just drew—evenly spaced; these will be the middle and ring fingers.

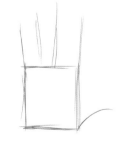
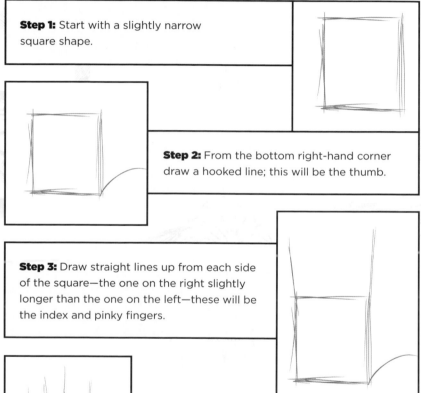

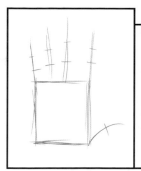

Step 5: Look at your own fingers to check the lengths of the ones you've drawn. The middle finger is the tallest, followed by the ring and index fingers, and then lastly the pinky. Look at the points where your knuckles are. Each finger has two knuckles—draw small lines to indicate those (and give the thumb one knuckle).

Step 6: Go around the skeletal lines you've set up to "fill in" the flesh.

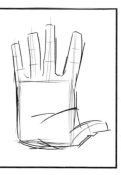

From there its easy to set up hands in all manner of "poses"—simply follow the design layout just established and bend or reposition the various fingers following the placement of the knuckles.

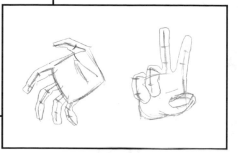

TIP:

You could alter the shape of the hands for different characters. Short stubby fingers give the impression of a cherubic or roly-poly figure, whereas long thin fingers tend to lean more toward evil or sinister creatures. Aging the hands can give the impression of a craggy figure.

The face

Drawing faces works in the same way as with figures and heads, beginning with the basic shapes.

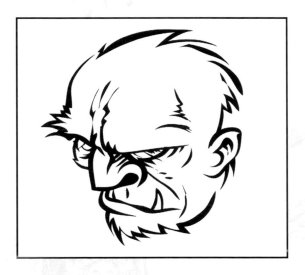

Step 1: This simple head is created using a combination of these shapes. Assemble these shapes into the base on which you will build the head.

Step 2: Use a soft lead nonphoto blue pencil to work in the details of the creature's face, keeping the lines fairly loose.

Step 3: Use a size 2 brush to add ink lines.

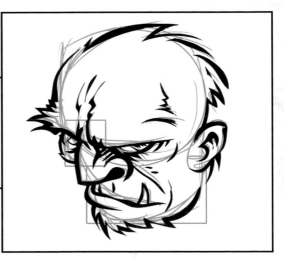

Other figures

One of the essential components of drawing supernatural beings is an ability to draw non-human creatures, and we can look to the animal (and insect) kingdom for inspiration in creating these otherworldly creatures.

Just as with the human figure, an animal figure begins with simple shapes and gesture lines.

Left, below, and right
The same principles for drawing the human form can be adapted to drawing animals.

It's a simple matter of combining creature anatomy to come up with fantasy creatures—a lion is built on the same anatomical fundamentals as a cat, only bigger, for example.

Above As with the human figure, using simple geometric designs helps us build up the basic shape.

Above Once you have the basic shape to work with you can start adding more detail.

If we take the head and neck of the lion, combine it with the torso and arms of a gorilla, and give our creature the legs of a lion with the proportions and overall design (standing upright) of a human, we get a Lion Warrior.

Right Lightly sketch out the creature using the techniques from the previous pages.

Using basic inking techniques (see pages 24–7) we can bring him to a finish.

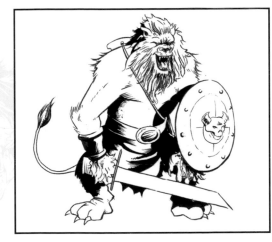

Left Combining the techniques on proportion for humans and animals will help you create a fantastic supernatural being.

Understanding the way to draw the human figure allows us to "humanize" a crocodile to make him a warrior along with our lion-man.

Above Combine human and animal elements to create a menacing creature.

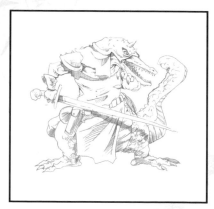

Above Once you are happy with the character you have created, ink in to finish off.

Texture plays an important role here—maintain the crocodile's reptilian nature by indicating his tough hide, which would itself be a built-in armor; however, giving him some additional armor fits in with the character style.

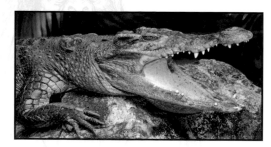

A. Head and skin texture of a crocodile

A trip to the zoo or a few hours watching Animal Planet would go a long way toward improving your ability to render creatures of the animal world. The key is practice. Focus not just on the animals you like, but the ones you are less interested in as well—it will make you a better artist if you can tackle any subject.

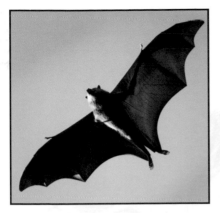

B. Wings of a bat

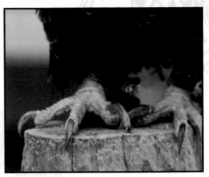

C. Claws of an eagle

Understanding the different elements of the animal world allows us to easily put fantasy and supernatural creatures together. You may not be able to find reference for a dragon without looking at someone else's illustration, but you can find the components needed to make up your own by combining some parts of different creatures.

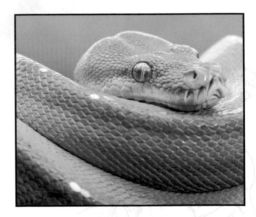

D. Snake

You now have an interesting take on a dragon. Give it a try!

Composition

Composition is one of the most important elements of good illustration. Let's look at some of the most basic rules.

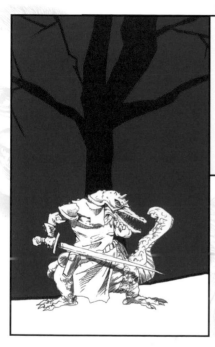

Step 1: Elements should not be placed on top of each other. In the case of this first example, having the tree directly behind the Crocodile Man makes the illustration appear somewhat stiff. It's also a good idea to keep your items off-center.

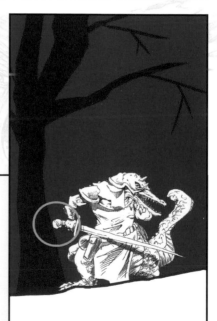

Step 2: Elements should not "kiss." In this example, the edge of the Crocodile Man's sword handle and the tree are kissing. It makes the illustration look fake or staged when this happens.

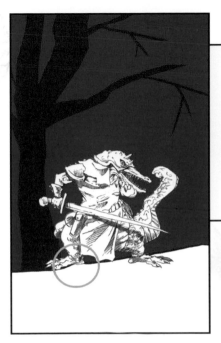

Step 3: In this third example we've moved the Crocodile Man so that his sword no longer butts the tree, and we've pulled the ground line up for balance... but now his foot kisses the edge of the ground line, making it look awkward.

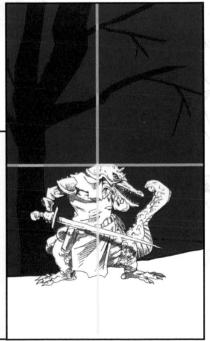

Step 4: This is the strongest version so far, but if we look at it by dividing the illustration into quarters, we can see that there is not much going on in the top right-hand corner of the piece. While you don't have to have something going on in all the space of the drawing, you should aim for a sense of balance in the piece.

Step 5: Adding a second Crocodile Man works for the composition because we get the sense that they are preparing for something coming at them from the right. It also takes care of some of our dead space in the top right-hand corner, but the back figure's foot conflicts with the foreground figure's mouth—which makes the illustration a little confusing. We've also lost the swords, so it isn't clear what they're holding.

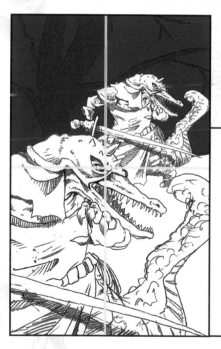

Step 6: By moving the ground line up farther still and repositioning the background figure, we've solved a couple of the problems; it's taken care of the foot-in-the-mouth problem, and now we're at least showing the sword on the background figure so that when we see it in the foreground character's hand we can understand what it is.

Cropping

Taking an illustration and re-cropping it to change the balance can be effective too. In this first example we have a stylized illustration of a man's face. The "portrait"-style illustration is centered, with a focal point just about dead center. The choice of a bright background color works well with the heavy black and stark white of the figure—using opposing colors like this makes it "pop" off the background.

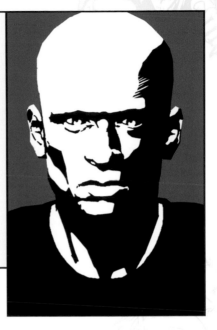

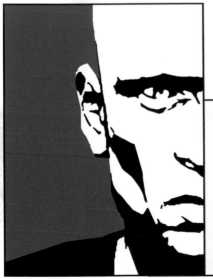

If we take the same illustration and tighten the crop, the illustration now makes the subject look much more intense, even though we haven't changed a thing with the drawing itself. The piece becomes more powerful, and the expression is greatly emphasized.

Movement

Depicting movement in your illustration is one step toward making your work stand out and be vibrant. Body language is also a huge part of effectively presenting your illustration. You are the movie director here, and your characters are your actors—you have to make sure they perform.

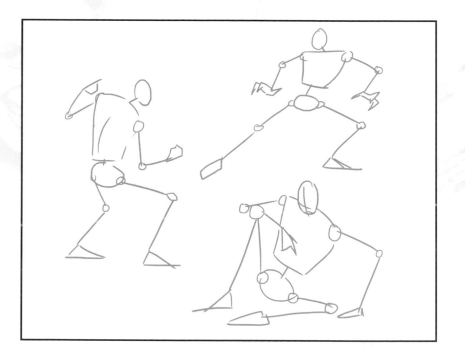

Above Showing movement is essential to making your characters look more realistic. Depicting movement can be done in several different ways: motion lines, muscle tension, clothing draping, and hair movement.

In addition to using the shapes to make up the figure it's important to study how those shapes react in real life. As the arm moves up the shoulder moves up with it (see right). This creates a sense of muscle and correct movement as you are posing your figure. If you only follow the ball joint and position your figure's arm so that it doesn't move, staying stiff like a cheap action figure, your drawings will appear awkward.

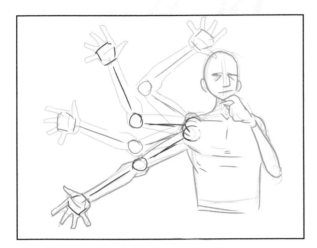

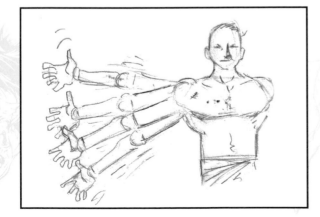

Left Blur the area of motion and draw phantom copies to show excessive movement.

A better way to approach motion in your illustration is to approach your illustration as you would a photograph—the pose vs. the candid shot. If someone knows you are taking their picture, they usually stiffen up and pose, and this results in a figure that looks unnatural and stiff—like the "packaged action figure," below.

Above This is a good place to start for an intitial character design which can be developed into a more natural pose.

Although this is a good solid quick sketch, it's more of a character design than the layout for a finished illustration. The figure looks like someone just told him to pose for the picture.

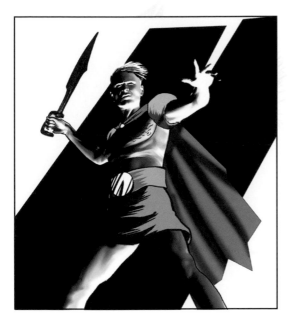

Left Taking the initial character design and adding movement and shading really brings the character to life.

This second one, above, is a stronger layout because now the figure is moving, and we've also moved the angle down a bit lower so we're looking up at him for dramatic effect. His cape is moving in the wind or because of his movement. The heavy emphasis of shadow on one side of the figure creates a better sense of drama as well.

Perspective

The world exists in three dimensions, and being able to effectively show that takes a very basic understanding of perspective. It's also a valuable aid in determining scale.

The horizon line is the viewer's eyeline—the area at which the sky intersects with the ground as we look into the distance.

To understand perspective try to envision a series of buildings in a big city facing you. The fronts all appear just as blocks.

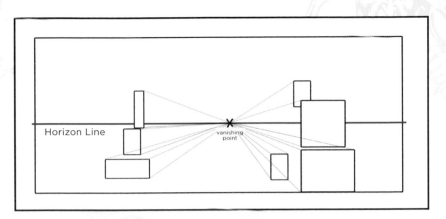

If we want each of these blocks to appear to be 3D, all need to follow back to a single point on the horizon line called a vanishing point.

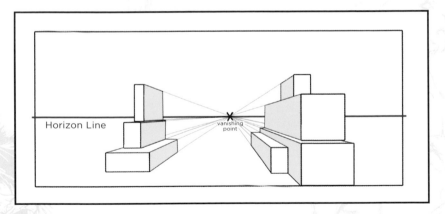

In order to give those buildings the appearance of depth, we need to follow those lines back toward the vanishing point (as shown in the figure at the top of this page) and close off the sides of the building which face the avenue so that they now have end lines (as shown in the figure above).

Emotion

Conveying the right emotion is important for getting the best out of your illustration. Let's take a generic character and examine how we can get an understanding of what he's feeling through his expression.

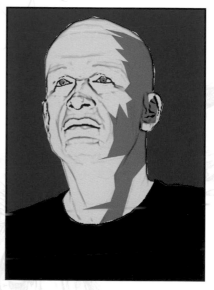

In the first example, our character has a vague, indefinable look on his face.

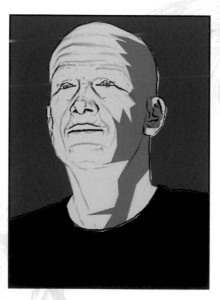

In the next, he seems slightly amused; it's subtle but noticeable.

In the last one his expression is more extreme—he seems to have a look of surprise or anger. Over-exaggerating an emotion is an effective technique.

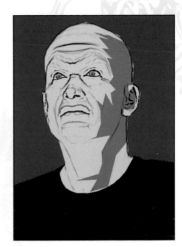

Expressions are a form of shorthand too. Let's look at some common expressions; we'll call these basic emotions:

 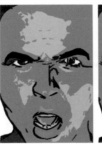

Fear	Anger	Disgust	Joy
Surprise	Trust	Sadness	Anticipation

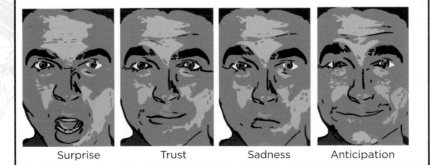

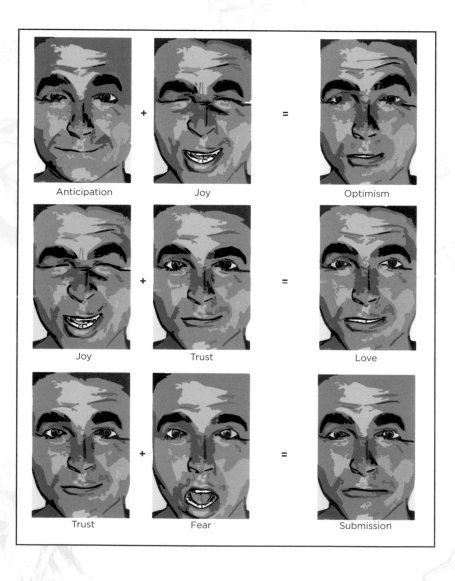

Anticipation + Joy = Optimism

Joy + Trust = Love

Trust + Fear = Submission

 + 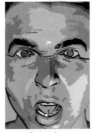 =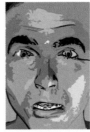

Fear + Surprise = Awe

 + =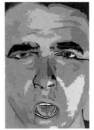

Surprise + Sadness = Disappointment

 + =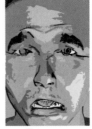

Sadness + Disgust = Remorse

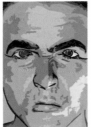 + 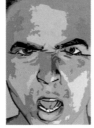 =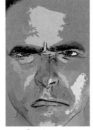

Disgust + Anger = Contempt

Tones

Tone is the effect of adding gray to black and white artwork, enhancing the artwork by emphasizing form, mood, or shadow.

First let's look at the effects achieved by adding tone:

Above Adding tone to a drawing gives it a sense of form. It's also a way of adding shadow without making the illustration too black, creating a sense of finish and atmosphere.

See the difference? Nicely placed tone can give the work a polished look and also creates a sense of form in your artwork, keeping it from looking too flat.

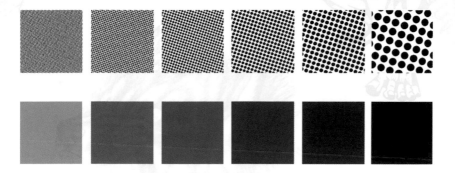

The degree of gray achieved above is based on the percentages of blacks and whites. These tones are sometimes made out of a series of screened dots and the amount of space between them determines the value of the gray color.

Keep in mind that when printing it is normal for grays to appear slightly darker (usually 10 percent) than what you might see looking at the original art—therefore you should always fall back 10 percent in setting your value—so, if you want your printed art to appear with a 40 percent tone you should apply a 30 percent tone on your page. Anything above 80 percent might as well just be black since you probably won't see any difference when it's printed.

Working with tones—what you'll need:

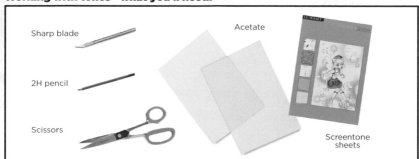

Sharp blade

2H pencil

Scissors

Acetate

Screentone sheets

Cross-hatching types

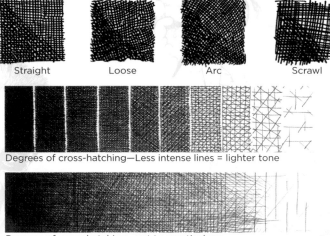

| Straight | Loose | Arc | Scrawl |

Degrees of cross-hatching—Less intense lines = lighter tone

Degrees of cross-hatching—put to practical use

Drawing tones

Tone effects can also be added by hand using line work, cross-hatching, or wash, which is watered down or thinned black ink. No matter how the gray is applied to your page it will be converted to dots in the printing process.

Tone effects

The goal of adding the tone can vary from artist to artist and from project to project. Tone can be used to suggest the time of day, for instance. This is how a panel looks without any tone added. Since it's just a line drawing we don't have any idea what time of day or night it is.

Here we have the same line art drawing but with some added tone to suggest a cloudy midday sky.

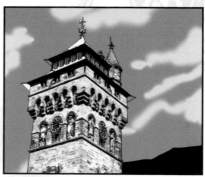

Taking the same base I've added a bit more dark tone to the castle itself as well as the sky, suggesting a time later in the day.

Even more tone has been added to the castle here, giving a suggestion of night. The windows appear lit from the inside.

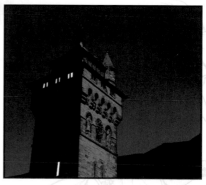

It's important when adding tone to suggest time that you predetermine the light source before you apply the tone. It's not enough to just drop a tone all over the page—that wouldn't be as effective.

Experiment—you'll be surprised at the number of effects you can achieve.

Color

Color sets mood and adds a whole other dimension to your work. Color can instantly trigger a sense of emotion:

BLUE—Night or sorrow

RED—Anger or heat

YELLOW—Fear or surprise

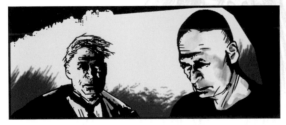

Good coloring is more than just filling in the black and white lines—it's about understanding the effect it adds—to be successful at coloring you must first understand the basic principles of color.

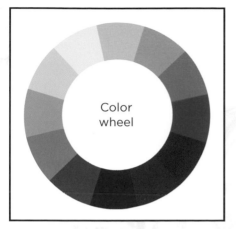

Color wheel

Complementary colors

Opposite colors intensify each other. Look at the color wheel, left—you can see that the opposite of green is red, of blue is orange, of purple is yellow, and so on. You can test this theory by choosing to invert a color image in Photoshop, which will show you the opposing color.

Hue

Hue is the value of the color of a given object. A pumpkin is orange, an apple is red, a banana is yellow, etc. Simply put, it's the first thing we think of when we imagine the color of an object.

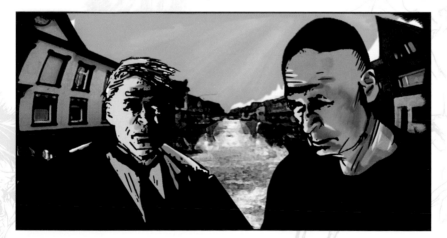

Above Hues don't need to be completely natural. It is fun to play with extremes in color, for a surreal quality.

Temperature

This refers to "warm" or "cool" colors. Reds, oranges, and yellows are all warm colors. Think of the colors of summer.

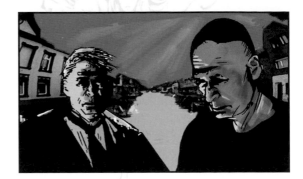

Blues, greens, and purples are all cool colors. Think of the colors of winter or night.

It's easy to create a sense of mood in your illustrations by ensuring you follow the temperature theory.

Saturation

Spoken plainly—this is how much color, or ink, you are using on your page. A piece of art with heavy color saturation can appear muddy, causing details to be lost, while an illustration with moderate saturation is a better choice for ensuring that the mood is set and we haven't lost any details. If too little saturation is used, this can cause the illustration to look washed out and faded. This is hard! But who said coloring was easy?

Depth

Above By having darker shades closer to your viewers "eye" with medium and light shades behind them we create the impression of depth.

Think of some far-off landscapes you've seen. The mountains in the distance seem to fade into the background sky, while those closer to us have a more intense value to their colors; they remain sharp because they are closer. This is a fantastic technique to use to give your work the necessary depth of focus.

In this example, I'm using only blacks, whites, and grays—but notice how the darker leaves seem to come forward and the faded ones disappear into the background.

Refining skills

You can find reference material in all kinds of places. Magazines, DVDs, and the Internet all have a nearly endless supply of images, but nothing is better than seeing something in person.

The zoo

When you want to draw a dragon, where do you go for first-hand reference? While most zoos are low in dragon or goblin residents, that shouldn't stop you. A trip to the reptile house will allow you to understand scales and snakeskin patterns that will be indispensable in creating a great dragon illustration. Study the way the skin hangs on the lizards while you're there too, and stop by the alligator section to see some great dragon-ish eyes.

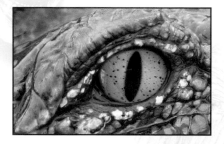

Left Do some close studies of different reptiles and adapt them to create a supernatural being.

Wings

If your supernatural being is going to have wings, you may want to study bat wings as valuable reference.

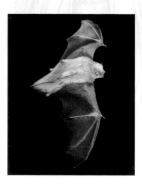
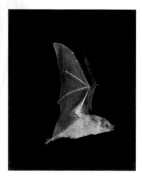

Skin

Deciding on the texture of your creature's skin will point you in the direction of possible real animals to research.

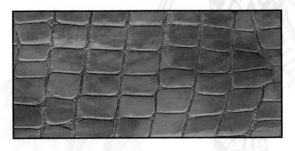

Horns

When drawing a demon the first step is to look at horns in real life, and examine how they interact with the animal's head.

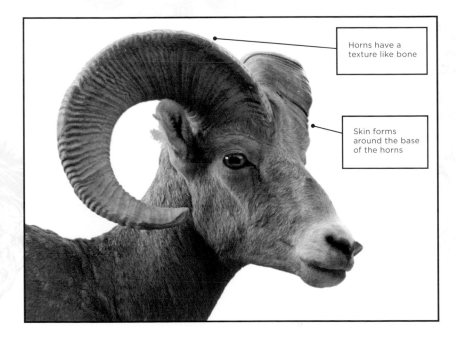

Horns have a texture like bone

Skin forms around the base of the horns

Zoo reference to supernatural creature

After gathering reference material from a zoo trip, put the various elements together to create your artwork.

Step 1: Start with a basic sketch of an ogre-like creature. Giving him a big square chin and a short forehead gives the impression he's got more brawn than brain.

Step 2: The best way to draw horns and to make them look like they have form is to start with a single base line that essentially begins at the center of the horn and goes to the tip.

Step 3: Then, starting from the tips of the horns back to the base draw the corresponding lines to indicate the roundness of each horn. We'll use this head design later on as we draw a full demon figure (pages 94–9).

Anatomy reference

From an understanding of how the human body is built comes an understanding of how it works, and therefore how it can move and pose.

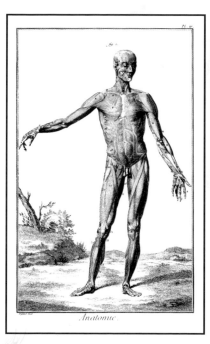

Anatomie.

Animal and human

Many supernatural creatures are combinations of animals and humans, such as a satyr, a being that is half man, half goat, and often sports large horns. To find reference for such a creature you need to find an adequate male figure, a goat, and some good horns.

TIP

Keep a scrapbook. When you see an interesting photograph in a magazine or a newspaper, clip it out and paste it into your reference scrapbook. You can also put in pictures you take yourself. If you're really organized you can even set up themed chapters, for example street scenes, textures, patterns, and interesting people.

Photoshop basics

Photoshop is one of the most powerful digital programs an artist can use, and has become the industry standard for creating and finishing all manner of illustrations. One of the best ways to learn how to use the program is simply to play around with it.

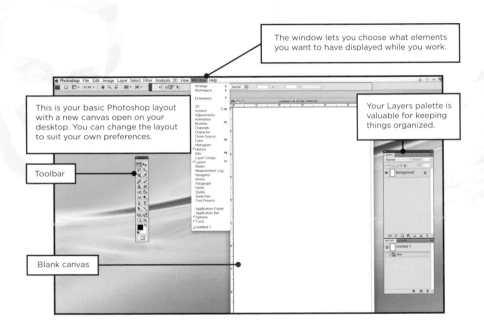

The window lets you choose what elements you want to have displayed while you work.

This is your basic Photoshop layout with a new canvas open on your desktop. You can change the layout to suit your own preferences.

Your Layers palette is valuable for keeping things organized.

Toolbar

Blank canvas

Toolbar

The Toolbar holds a lot of tools, and Photoshop uses the hidden multilevel method to keep the Toolbar from taking up the whole left-hand side of the screen. Simply hold down the mouse over one of the tools and the hidden tools will pop up; you can then slide the mouse over to the tool you want to use.

TOOLS, TECHNIQUES, AND BASIC SKILLS

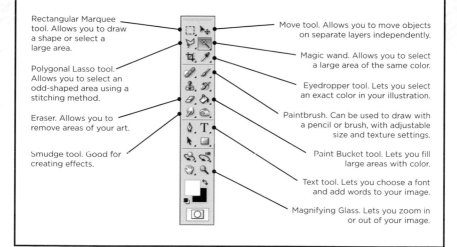

Rectangular Marquee tool. Allows you to draw a shape or select a large area.

Polygonal Lasso tool. Allows you to select an odd-shaped area using a stitching method.

Eraser. Allows you to remove areas of your art.

Smudge tool. Good for creating effects.

Move tool. Allows you to move objects on separate layers independently.

Magic wand. Allows you to select a large area of the same color.

Eyedropper tool. Lets you select an exact color in your illustration.

Paintbrush. Can be used to draw with a pencil or brush, with adjustable size and texture settings.

Paint Bucket tool. Lets you fill large areas with color.

Text tool. Lets you choose a font and add words to your image.

Magnifying Glass. Lets you zoom in or out of your image.

You will notice that most of the tools on the toolbar have a little black arrow in the bottom right-hand corner. That means there are more tools underneath; if you hold your mouse down on the tool the hidden tools will be revealed.

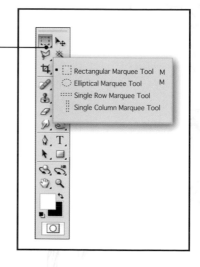

Layers

Follow this sequence to experiment with Photoshop's layers.

Step 1: Open a new document (File> New>8 x 10 inches at 300 dpi). To add a layer go to Layer>Layer button in the Layers palette. A new layer will be added above the base layer, or whichever layer you were working on. It is important that you keep track of which layer you are working on.

Alternatively, you can click this little button on the Layers palette.

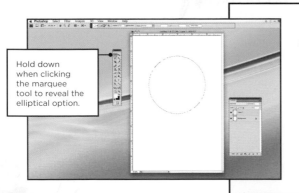

Hold down when clicking the marquee tool to reveal the elliptical option.

Step 2: Take the Elliptical Marquee tool and draw a circle in the center of your canvas. This circle is on the upper layer visible in the Layers palette.

Step 3: Click on the Color Box; the Color Picker appears. Once you have your color, click OK. Then fill the circle with paint—click on the Paint Bucket icon on the Toolbar, then select your color.

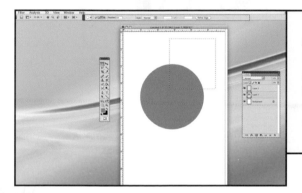

To make the "marching ants" go away, go to either Select> Deselect or press the Apple (command) key + D on a mac or Control + D on a PC.

Step 4: Add another layer and this time use the Rectangular Marquee tool to draw a square on this new layer.

Step 5: Use the Paint Bucket to fill the new square with yellow paint.

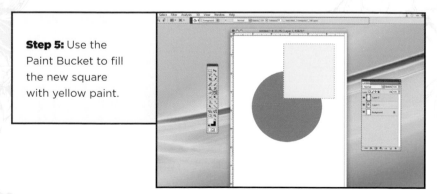

Step 6: At the top of the Layers palette is a box with a blue button that defaults to "Normal." While on the yellow square layer, click on the button and change it to Multiply, then watch. The yellow block is now transparent and the blue shows through as green.

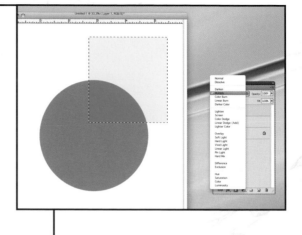

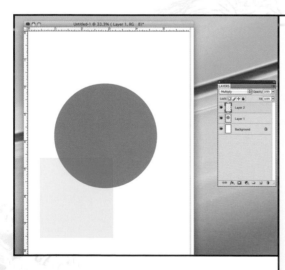

Step 7: Each of the colors is on a separate layer, which allows you to move them individually. Use the Move tool to move the yellow box around the canvas. This is effective in reconfiguring your compositions, so keeping your objects as separate layers is always a good idea.

SAVING

It is critically important to save your work often. Always rename any project you are starting the moment you begin and then every five or six steps after that. It's never a good idea to leave something named "Untitled" because it is much too easy to overwrite or misplace.

When saving your work, TIFF files or PSDs are the best options. They maintain their resolution, while JPEGs, BMPs, and PNGs compress your image with each save, resulting in a loss of picture clarity after just a few re-saves.

Photoshop project

This project details the common tools and techniques you can use in Photoshop to create great drawings of supernatural beings. It features Charon, the figure who leads souls to the Netherworld down the River of Purgatory. The elements needed to make this illustration work are: Charon; a boat; a creepy environment; and a newly departed soul.

Step 1: Before opening up Photoshop, work on a few initial sketches. In this instance three sketches are considered. The first sketch might be cropped a little too tightly. Although it does portray Charon and the boat, it could be a bit more dramatic. The second sketch has a bit more flair to it, but Charon looks like he's seasick. The third sketch is more suitable, and will be supplemented with a lantern to add some drama.

 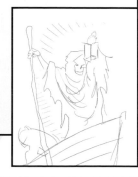

Step 2: Create a new Photoshop file to work in (File>New>8 x 10 inches at 300 dpi). You can either use Photoshop as an aid to complete a pencil sketch that you scan in, or you can draw your image completely in the program using a digital tablet.

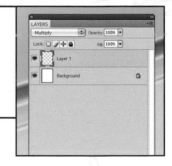

Step 3: Add a layer to your canvas, either by going to Layer>New Layer or by selecting the Layer button in the Layers palette.

TIP

Wacom's Bamboo Tablet is a great tool for working digitally. Don't let its inexpensive price tag fool you; this is a powerful utensil for any artist and will allow you the most freedom if you want to draw digitally.

Step 4: Select a brush from your Toolbar and then in your Brush Options (located at the top of your screen) select a size 9 Round brush set to 100% hardness. This will give a nice clean and sharp edge to work with.

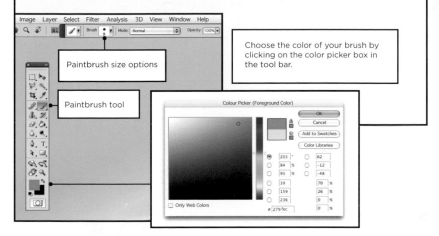

Paintbrush size options

Paintbrush tool

Choose the color of your brush by clicking on the color picker box in the tool bar.

Step 5: Start by drawing some basic shapes to build the figure. Note that even though a lot of the figure will be covered in a shroud you should still draw the arms and legs, since this is essential in ensuring that the figure maintains its correct proportions.

Step 6: Work in the loose outlines of Charon's cloak and give him a lantern.

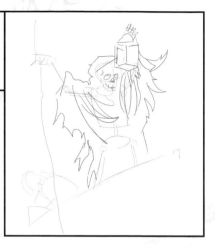

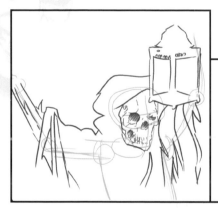

Step 7: Add another layer. To start working in the details, switch to gray using the Color Picker and use the same paintbrush to draw with. Zoom in (View>Zoom In) to get up close and make it easier to work.

Step 8: Zoom out (View>Fit on Screen) to work on other parts of the drawing and fill in additional elements. The figure in the back of the boat should be shadowy, since it represents a newly departed soul.

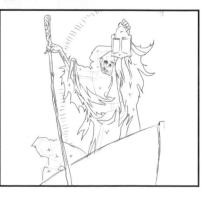

Step 9: Before inking, make sure you are on the correct layer. Then go to Image>Adjustment> Brightness/Contrast and adjust so that the gray drawing darkens to black.

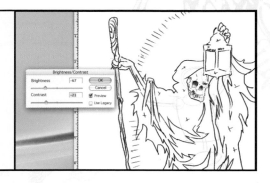

Step 10: Filling in large black areas of a drawing is easy with Photoshop. Use the Polygonal Lasso tool, which works like a needle and thread, so that each time you click the mouse it "locks" a line down into the drawing. Select an area in the drawing (highlighted in yellow for display purposes only), carefully going around the edges and back to the original starting point. The blinking line of marching ants now outlines the section selected.

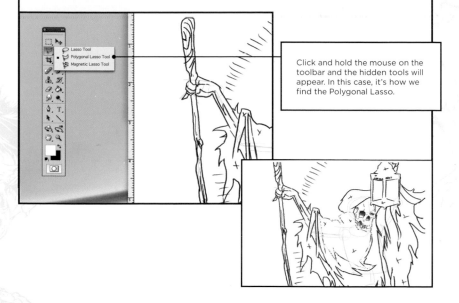

Click and hold the mouse on the toolbar and the hidden tools will appear. In this case, it's how we find the Polygonal Lasso.

Step 11: Select the Paint Bucket and click inside the blinking line to fill the area with paint. Go to Select> Deselect, then go to the next section and repeat Steps 10–11 until all the black areas are filled in.

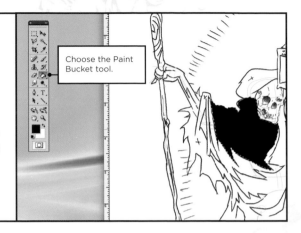

Choose the Paint Bucket tool.

Step 12: Delete the layer with the blue lines and return to the size 9 paintbrush to add in some fine details.

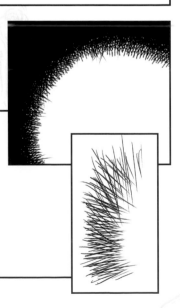

Step 13: The drawing needs more background shadow to give a sense of menace. Open another canvas (8 x 10 inches at 300 dpi). Creating a cross-hatch digitally is the same as cross-hatching with pencil and paper. Keep the lines smooth and fluid, and build up gradually to increase the darkness.

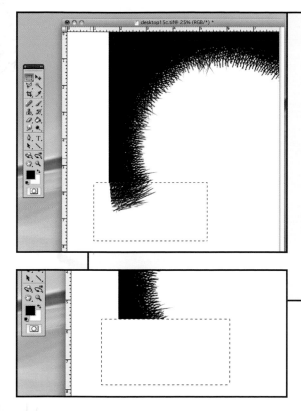

Step 14: You can use the Rectangular Marquee tool to clean up the bottom edge of the cross-hatching. To do this, draw a rectangular box on the image, then press Delete on the keyboard. The result is now a clean bottom edge. Use the Eraser tool to clean up the lines just drawn, making a cleaner, neater circle.

Step 15: To make a duplicate of this cross-hatched semicircle, saving the trouble of drawing all those cross-hatch lines again, make sure the layer you want to duplicate is selected (highlighted in blue), then go to Layer> Duplicate Layer. This creates a copy of the chosen layer.

Step 16: To flip this image vertically and make a circle, go to Edit>Transform>Flip Vertical. At this point you can use the Move tool to move the duplicate layer into the position you want. You can make the cross-hatching an even circle, or leave it uneven—it's up to you.

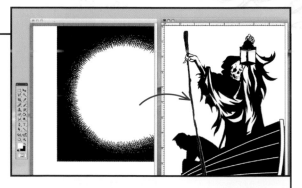

Step 17: Once you have the image the way you want it, select both layers that have the cross-hatch (with a Mac you do this by holding down the Command key, with a PC you hold down Control) and go to Layer>Merge Layers. This will combine the two layers into one. Select the Move tool and click on your image. Hold the mouse down while dragging the cross-hatching onto the Charon image.

Step 18: New layers dragged into another file will automatically go to the top of the image —if you look at your Layers palette you can see that layers shown at the top sit above layers listed below. Click and hold your mouse on any of these layers and drag them up or down. You can also move the image around.

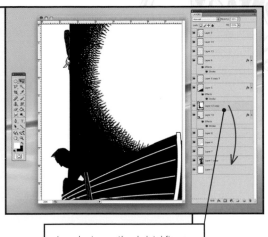

In order to see the skeletal figure on top we'll need to drag this new layer down below it.

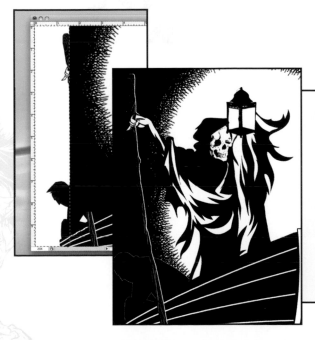

Step 19: The final step is to use the Rectangular Marquee tool again, this time to select the blank area to the left of the image. Then use the Paint Bucket to fill the area with black.

CHAPTER 2

GOBLINS
AND DEMONS

Some of the oldest supernatural creatures are
demons (sent by the devil to torment the living),
and goblins (grotesquely evil phantoms of
Northern European origin).

Goblins

Goblins are thought to be either mischievous or grotesquely evil. Sometimes portrayed as small, imp-like creatures resembling a gnome, they can also be depicted as heavyset frog-like beings.

Step 1: Start by drawing in some basic shapes that capture the goblin's overall stockiness and bad posture. Most folklore seems to agree that goblins have long pointy ears, so let's go with that. Keep lines nice and loose to start with.

Step 2: Work in some details, still keeping things pretty loose. Work in a vest and a belt. Since goblins are nocturnal creatures, he'll need big eyes, giving him that slightly frog-like appearance, but with a human nose.

Step 3: Add some bumps and texture to his skin— he should be somewhat slimy, with some stray hairs coming from his ears. Goblins are purported to carry weapons sometimes, so give him a big knife, but to keep it goblin-ish add finger holes to the handle and wrap it in tape or cloth.

NOTE

The sheath that holds the knife appears to be hand-stitched with a rope coil that holds the knife on the goblin's belt. Goblins probably wouldn't have the most high-tech equipment, so this handmade feel works for the character. Details like this will make your illustration stronger.

Step 4: Go over the drawing with black ink, working in some more details, such as his sandals, which are also handmade.

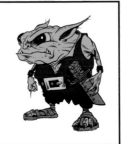

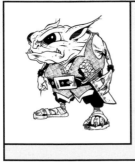

Step 5: The final step in the black-and-white illustration is to fill in the large black areas of the drawing and add some texture to the vest using patch-hatching. Notice how making his pants and belt black give the drawing a more finished look.

Step 6: Use a brush and colored inks to add color, using a palette that mimics that of a lizard-like creature, while choosing a warmer color for the vest. Once finished, let the illustration dry thoroughly before moving onto the detail, since you don't want to smudge any of the ink.

NOTE

Colored inks are applied by hand in this example, however you could accomplish much the same thing working digitally. You'll find more information on working in this way in the Demon project on pages 94–9.

Step 7: Choose a light source and add shadow to the area opposite it. With colored inks you can do this by mixing a little of a darker shade on top of the lighter, drier inks. In this case the light is coming from the right of the picture, so the left side of the figure is darker. Let the shadow area dry completely, using a hairdryer set on low to speed the process if you like.

TIP

Make sure you use a very clean brush and a minimal amount of water to ensure a good even flow of color.

Step 8: The final step is to add highlights to the figure. Since the light is coming from the right, that is where the highlights will be. Using acrylic paint and very little water, work in the highlight areas on top of the dry ink painting. Using the acrylic straight from the tube or bottle in very small amounts allows you to build up highlight areas. Acrylic dries fairly quickly so it's great to work with.

TIP

Take good care of your brushes and they'll last for years. Proper washing is simple. Run some warm water from a faucet and put a dab of dishwashing soap in the middle of your cupped palm. Take the brush in your other hand and gently work it in the soapy water. Rinse the brush and return it to your palm, taking care not to bend the bristles. Rinse again and continue with the same process until the water runs clear. Store brushes with the bristles up, never with them down, since this will ruin the brush.

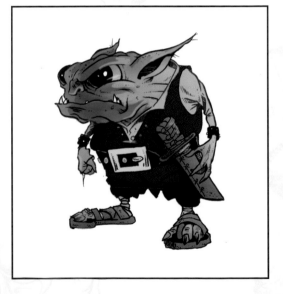

Demons

Demons are supernatural spirits or creatures, usually linked to Satan and his minions in the Netherworld.

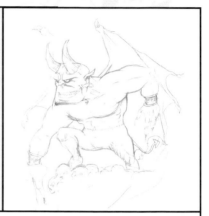

Step 1: Begin by making a few sketches. In this example the first sketch sees the demon—the big-jawed, brawny type—standing on a cliff of human skulls. While the pose is interesting, it is a bit stiff. A second sketch sees him in a more relaxed pose, sitting on the edge of the skull cliff and looking back at us, as if we have caught him on an off moment. This composition is better, giving more of a sense of the power of the demon, partly because his huge back muscles are on view. Note the horse hooves for feet.

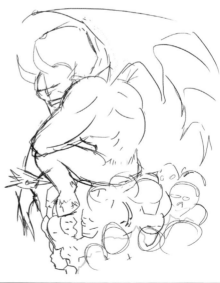

Step 2: Enlarge the rough sketch on a photocopier and use a lightbox to transfer it to 3-ply Bristol board. Work in some of the details in pencil. We will use reference for the skulls, so will come to the cliff details later.

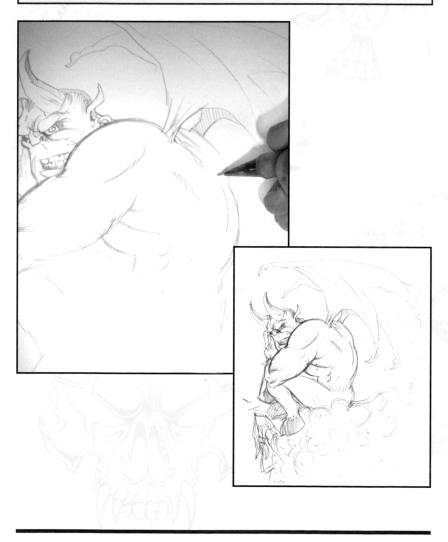

Step 3: Put down black ink using conventional brushes and a Pentel brush pen. Use a broader brush to fill in large black areas and a very thin brush to work in the fine lines of the demon's lower body. Source reference material for a skull and use it to help you draw the cliff surface.

Step 4: The color will be added in Photoshop. Scan in the image and open a new document (File>New>8 x 10 inches at 300 dpi). Add a layer (Layer>New Layer) and fill in the base colors.

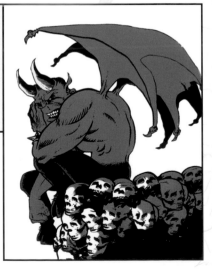

NOTE
Techniques for working in Photoshop are covered in detail on pages 74–87.

Step 5: Go to Image> Adjustment>Brightness/ Contrast and bring the color down a notch—click OK. Then add a layer set to Multiply and paint in some gray shadows with Soft Brush to help with the form.

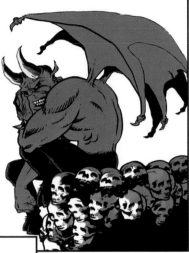

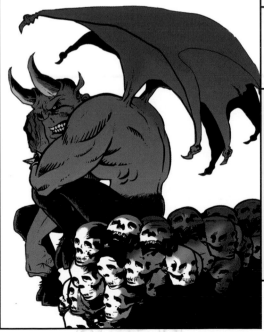

Step 6: Add another layer (also set to Multiply) and work in some darker reds throughout the illustration for dramatic effect. It's a clever way of showing subtle shadow on your piece.

Step 7: To add background color to the illustration, go to your background layer and zoom in. With a very small hard brush and some black paint close up any open lines around the outline. You need to do this so you can select all of the white but not the demon itself. Using the Magic Wand tool click in the background area. To select other areas at the same time, make sure the Add to selection option is selected from the top tool bar. You'll see the 'marching ants' on the areas that are selected.

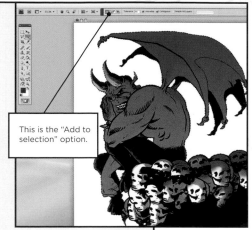

This is the "Add to selection" option.

Step 8: Add a layer and use the Paint Bucket to fill the area with a brownish color. Then select a 59 Splatter Brush enlarged up to 83 pt, and draw in a few streaks of lighter color. Because the areas are selected you will be able to paint broadly without any of the strokes affecting the main drawing of the demon.

GOBLINS AND DEMONS


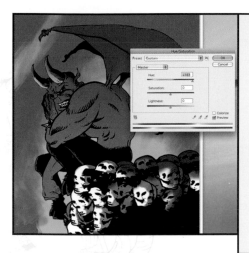

Step 9: Go to Image >Adjustments>Hue/Saturation and move the Hue bar up and down—the background colors will change as you slide the bar. Choosing a blue/purple background color makes sense here; the main figure features warm colors, so a cooler background will make it "pop." To let go of the selection, go to Select>Deselect.

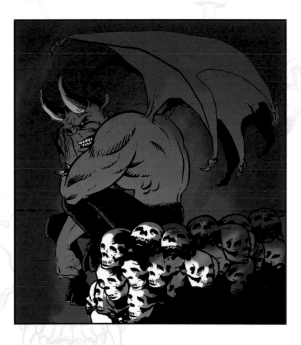

Djinn BY PETER TIKOS AND RICHARD VASS

A *djinn* is a supernatural creature in Arab folklore that occupies a parallel world to mankind. *Djinns* have been described as creatures of different forms; some resembling vultures and snakes, and they may even appear as dragons, or take human form. Like humans, the *djinn* can be good or evil.

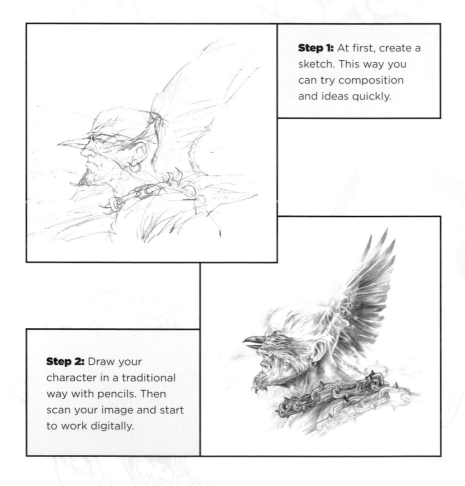

Step 1: At first, create a sketch. This way you can try composition and ideas quickly.

Step 2: Draw your character in a traditional way with pencils. Then scan your image and start to work digitally.

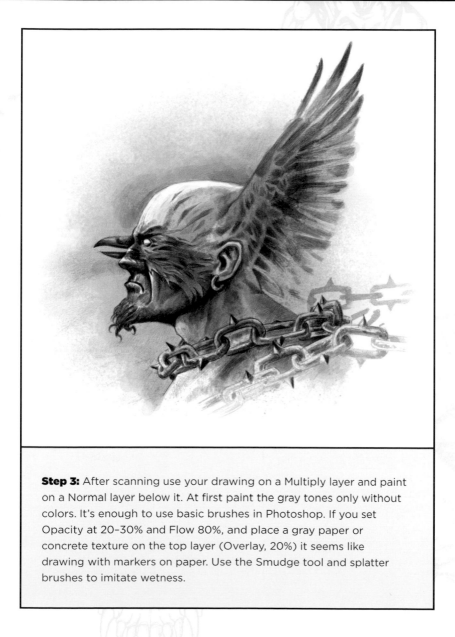

Step 3: After scanning use your drawing on a Multiply layer and paint on a Normal layer below it. At first paint the gray tones only without colors. It's enough to use basic brushes in Photoshop. If you set Opacity at 20–30% and Flow 80%, and place a gray paper or concrete texture on the top layer (Overlay, 20%) it seems like drawing with markers on paper. Use the Smudge tool and splatter brushes to imitate wetness.

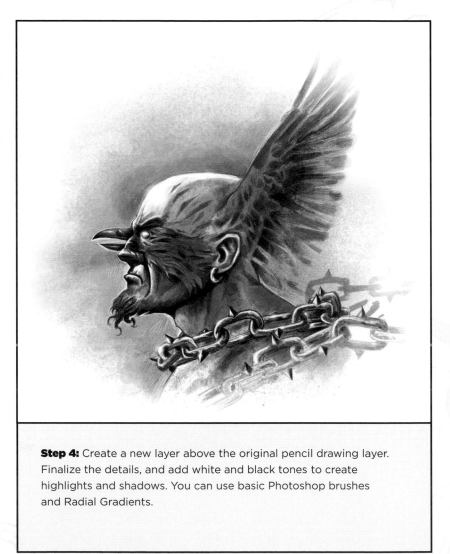

Step 4: Create a new layer above the original pencil drawing layer. Finalize the details, and add white and black tones to create highlights and shadows. You can use basic Photoshop brushes and Radial Gradients.

Step 5: Colorize the grayscale image with Color Balance Adjustment layers. The cold blue and the warm orange tones are working well together. Using gradients you can make fine and smooth color effects.

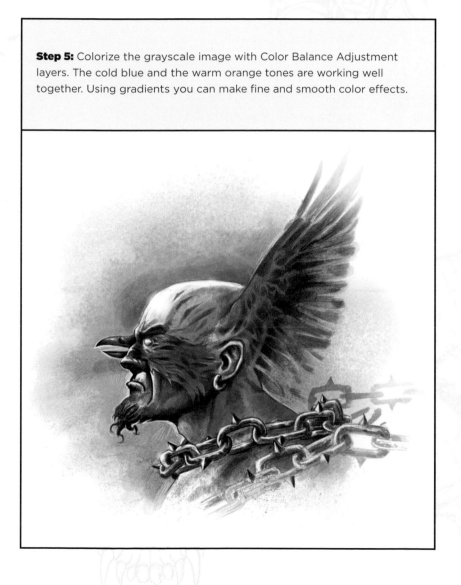

Step 6: Add more warm colors using a Color Balance Adjustment layer and photos of fire as Overlay or Screen layers.

Step 7: Add more cold colors to the background.

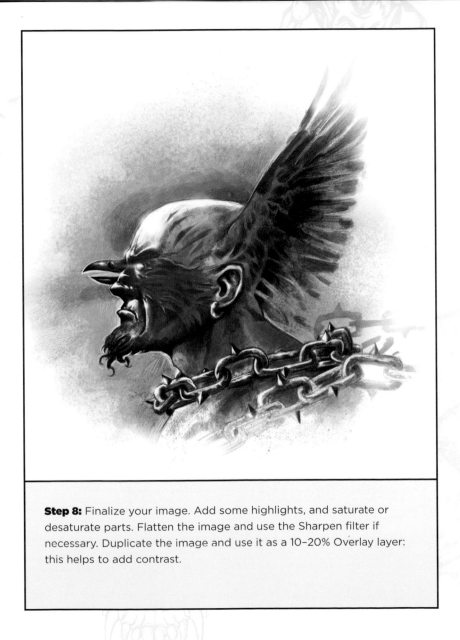

Step 8: Finalize your image. Add some highlights, and saturate or desaturate parts. Flatten the image and use the Sharpen filter if necessary. Duplicate the image and use it as a 10–20% Overlay layer: this helps to add contrast.

CHAPTER 3

GHOSTS AND GHOULS

Death and the afterlife are terrifying enough without adding evil spirits who return from the grave. This chapter covers the most haunting of ghosts and ghouls.

Ghosts

A belief in ghosts dates back to ancient Egypt, where the idea of final death was unthinkable and it was thought that the ghost would live on in the tomb of the departed. It was even believed that the wealthy would need servants with them in the afterlife, so was common for slaves to be buried alive with their masters to continue their service. The traditional manner of thinking of ghosts is one covered in a sheet with a couple of eyeholes cut out. While this is perfectly acceptable, it won't make for a fascinating illustration.

Step 1: Open a new blank canvas in Photoshop (File>New>8 x 10 inches at 300 dpi). Use the Paint Bucket to fill the canvas with black paint. Next, add a new layer (Layer>New Layer) for the base.

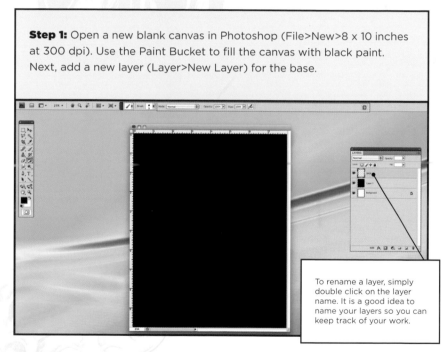

To rename a layer, simply double click on the layer name. It is a good idea to name your layers so you can keep track of your work.

TIP

Take a field trip to a local cemetery, either with a sketchbook or a camera, and build your own reference library of interesting tombstones. They'll come in handy and you'll stop drawing grave markers like upside-down Us.

NOTE

For this piece we're going to work digitally, but the same effects can be accomplished with watercolor and acrylics. Techniques for working in Photoshop are covered in detail on pages 74–87.

Step 2: Select a light blue from the Color Picker and choose a size 9 Hard Round brush. This is the brush you will sketch the drawing with. Keep the ghost figure loose and sketchy. Use blue lines for the base figure shapes, and change to red for the folds of the shroud. Notice how the folds "bunch up" at the bend of the arm and then flow from the wrist downward to give a sense of motion.

Step 3: Add a new layer underneath the base one. Select the Polygonal Lasso tool and trace around the outer edge of the figure. Use the Color Picker to choose white and the Paint Bucket to fill your selection with white paint. Go to the Layers palette and adjust the Opacity bar down from 100% to 65%—you will notice that the white you have just painted will fade.

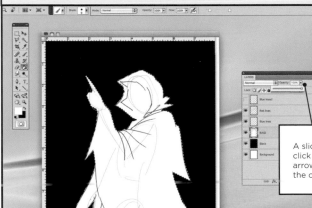

A slider will appear when you click the blue drop-down arrow which lets you change the opacity to any percentage.

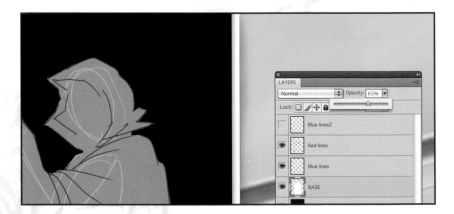

Step 4: Select the Brush tool, click on the blue drop button on the option box, and choose the 59 Splatter brush. You can alter the brush size by sliding the Master Diameter bar to the left or right. Move the bar up to 80. Over to the right, click on the Opacity bar and slide it down to 55%—this will allow you to apply a more ghostly layer of paint.

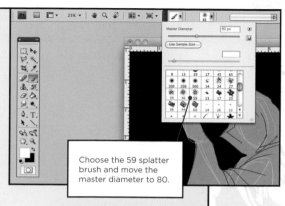

Choose the 59 splatter brush and move the master diameter to 80.

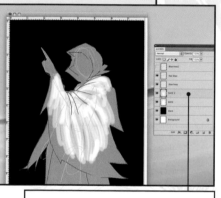

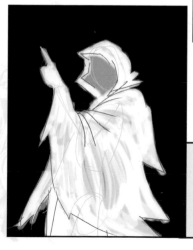

You can build up the white paint in different layers if you wish. This means you can easily delete areas you are not happy with.

Step 5: Keep working the brush strokes on the figure to create a sense of form on the ghost's shroud.

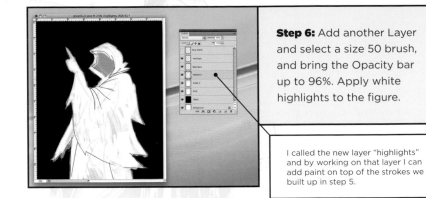

Step 6: Add another Layer and select a size 50 brush, and bring the Opacity bar up to 96%. Apply white highlights to the figure.

I called the new layer "highlights" and by working on that layer I can add paint on top of the strokes we built up in step 5.

Step 7: Add a new layer for the green, and change the setting to Multiply. Now, with a size 35 Soft Round brush, add the green areas to the shroud, working in shadow through the folds.

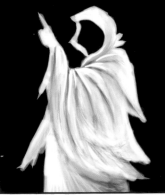

Add a layer (name it "green") and then change the layer from normal to multiply. This will allow us to add shadows to the form and since the layer is multiplied we'll be able to see the layers underneath it.

Step 8: Add another layer and leave this one Normal. Choose black with the Color Picker and a size 50 Hard Round brush. Color in the face and work in the folds.

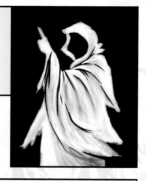

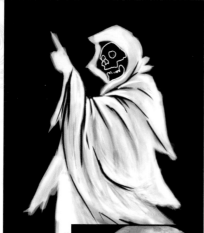

Step 9: Source reference material for the ghostly skull face and use white paint and a size 9 Round brush to mimic the shapes of the skull from the reference image. Using artistic license, here the mouth is pulled open to give a scarier look, and two red dots added for eyes.

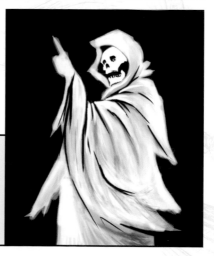

Step 10: Fill in the outline with white, being careful to keep the shape of the skull. Draw in some teeth with a Size 5 brush.

Ghouls

These creatures are thought to live in tombs and graveyards, feeding on the bodies of the dead.

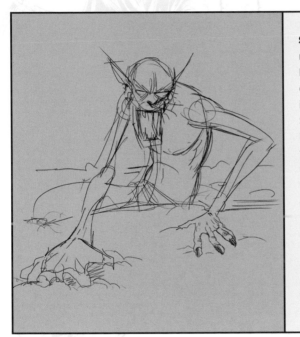

Step 1: Open a new canvas in Photoshop (File>New>8 x 10 inches at 300 dpi). Start by using the Paint Bucket tool to fill the canvas with a neutral color. This will make it easier to add depth and dimension. Add a layer (Layer> New Layer) and sketch in your ghoul using a Hard Round brush.

NOTE

Techniques for working in Photoshop are covered in detail on pages 74–87.

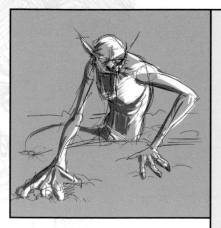

Step 2: Add a new layer for lights and one for darks. To build up the form of the creature, begin by working in large blocks of light and shadow. Work on the respective layers to add this shading. You'll need to understand the basics of form and anatomy to do this well, so it is a good idea to source some figure reference. Choosing a light source gives a good opportunity to work in form; in this case the light is coming from the right.

Step 3: Add a layer for details, then zoom in (View>Zoom In) and start working on the details of the face and the rest of the character, still working in fairly broad strokes but cleaning and tightening things up a bit as you go.

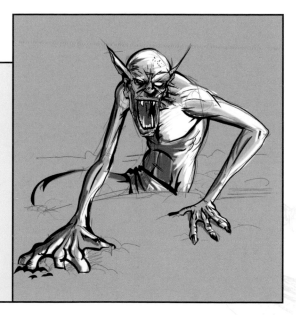

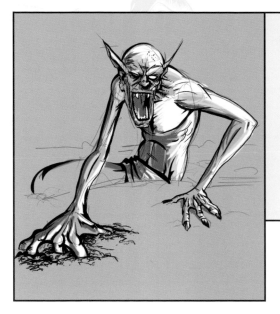

Step 4: Because the ghoul is coming up out of the dirt, you will need to work in some ground details. Start by working in some very loose sketchy lines under the hand in the foreground to indicate the texture of the ground.

Step 5: Continue the ground details around the rest of the figure, still using this "scumbling" method of loose sketching.

Step 6: Erase those loose sketch lines used to draw the figure by deleting the whole sketch layer, and add a bit of drool in the creature's mouth.

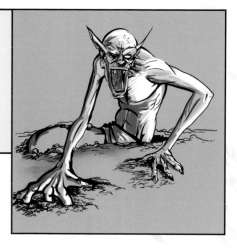

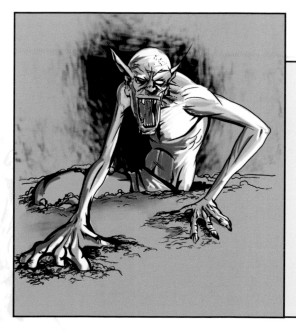

Step 7: To give the piece more atmosphere, use a new layer and a 59 Splatter brush to add in some dark shadows behind the figure—you can easily erase any shadows that end up covering the figure itself.

Banshee BY PETER TIKOS AND RICHARD VASS

The Banshee is a female spirit in Irish mythology, usually seen as a messenger from the Otherworld, her cry heralding someone's death. This project will focus on creating an illustration that brings this terrifying cry to life. It will also help the reader to develop their understanding of expression and movement.

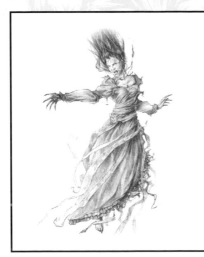

Step 1: Create the basis of your image with pencil on paper.

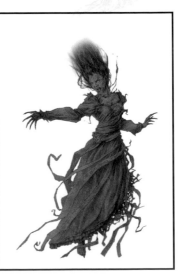

Step 2: Scan your graphics. If you make it a Multiply layer, you can paint below the image on a different layer. Paint the figure with a simple gray color.

Step 3: Create a Normal layer above the basic gray layer and create a Clipping Mask. You can paint gray tones on this layer. This layer helps you to remain inside the outlines of the figure.

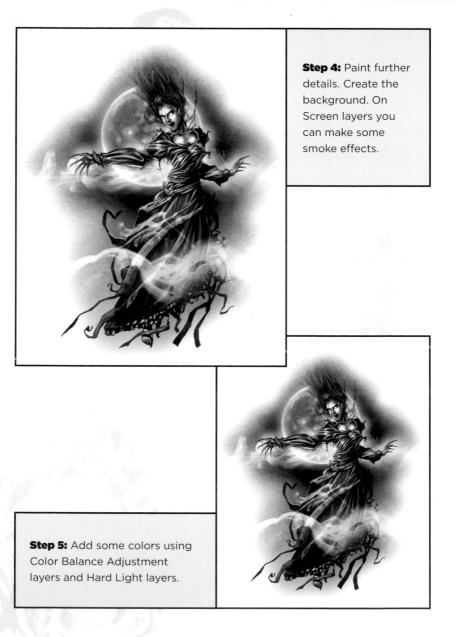

Step 4: Paint further details. Create the background. On Screen layers you can make some smoke effects.

Step 5: Add some colors using Color Balance Adjustment layers and Hard Light layers.

Step 6: Modify the saturation with Hue/Saturation/Lightness layers. You can create the atmosphere of the picture using the Gradient tool and soft brushes.

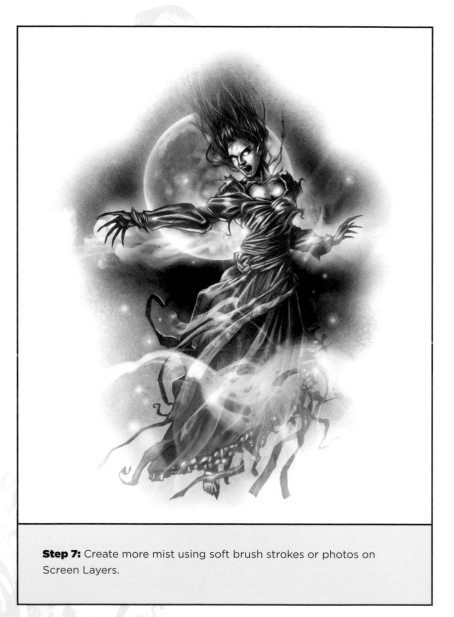

Step 7: Create more mist using soft brush strokes or photos on Screen Layers.

Step 8: Finalize the image. Paint highlights and modify the colors with Adjustment layers. Flatten the image and use the Sharpen filter if it's needed. Duplicate the image and use it as a 10–20% Overlay layer: this helps to add contrast.

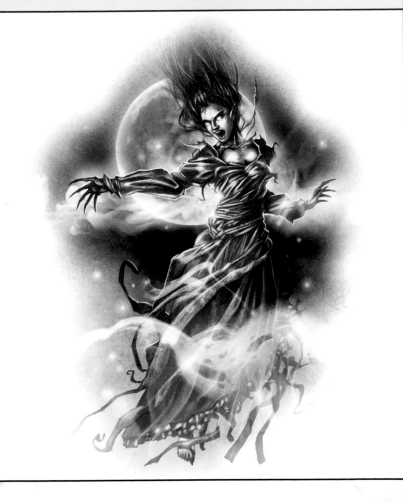

CHAPTER 4

WEREWOLVES
AND SHIFTERS

Part human and part animal, werewolves and shape-shifters can be drawn at any stage of their transformation from human to beast, meaning the artist has a whole range of possible subjects.

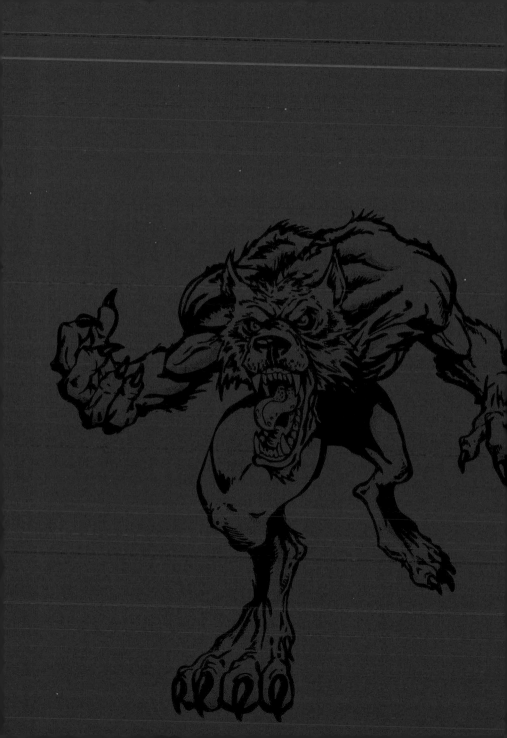

Shape-shifters

A belief in werewolves and shape-shifters dates back to mankind's earliest records. While a werewolf is a man who transforms into a wolf, a shape-shifter is a creature that can take virtually any form—man or beast. Native American Indian tribes were firm believers in the ability of certain creatures to completely change form.

TIP

For shape-shifting creatures there is no better reference than the real thing—a trip to the zoo can help you with illustrating lions, tigers, and bears (and wolves).

NOTE

This project uses gouache, a smooth and opaque paint that can be applied in very thin coats, like ink. It is available in tubes of assorted colors, like acrylic paints, but is closer to watercolor in feel and application.

Step 1: Work up a sketch of your figure, in this case a tiger–man. It is always best to depict a figure in action, so pose him as if he's getting ready for battle. For the sake of the demonstration the lines here are shown fairly dark, but you should try to keep your pencil lines light and loose for easy erasing later.

Step 2: Working from these very loose pencil drawings, and without getting much tighter, start to ink in your drawing using a small brush and black ink.

Step 3: When the inking is complete, allow the piece to dry thoroughly, then erase your pencil lines with a soft white plastic eraser, to leave clean brush lines.

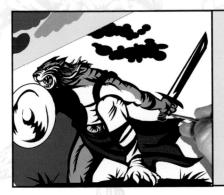

Step 4: This piece is colored traditionally using gouache paint. Set up a piece of scrap paper and make sure your brush is very clean. On the scrap paper, work up the color with the brush so that it can flow smoothly. Do not use a damp brush, since this will cause the paper to buckle.

Step 5: Work evenly with a clean, dry brush for each color to achieve rich, smooth, and fluid colors. Let the painting dry completely.

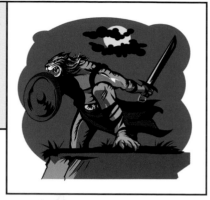

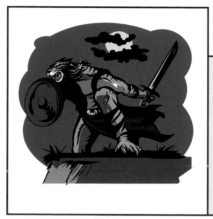

Step 6: When the painting is dry, mix a little blue into each of the previous color choices, then add shadow to each of the colored areas. Again, working with a clean, dry brush each time makes all the difference in keeping the color smooth.

Step 7: To add a light glare on the tiger's saber, mask off the area where the glare will be with tape, such as a clear or colored painters' tape, which is available in a variety of sizes and colors. Use a craft-knife blade to carefully cut out the shapes for the glint of light from the tape.

Step 8: Make sure the tape is attached securely, then dab white acrylic paint onto the cut-out area.

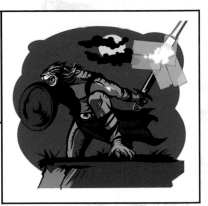

Step 9: Let the white paint dry completely, then carefully pull the tape off the drawing. The white paint will stand out brightly on your illustration.

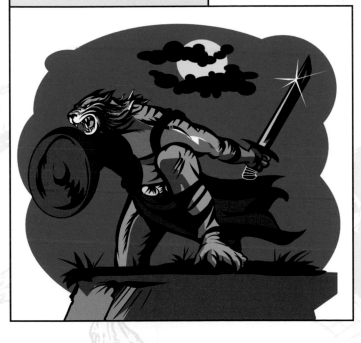

Werewolves

The more traditional version of the werewolf, recognizable to many in the Western world, comes from Eastern European folklore, with a lot of influence from twentieth-century Hollywood movies.

When drawing a werewolf you will need to decide how much of him is wolf and how much is man. It has become increasingly popular to depict werewolves as almost complete wolves walking on their hind legs, harking back to some of the earliest depictions of werewolves, such as those on sixteenth-century woodblock prints.

Left This eighteenth-century woodcut by Ian Woodward depicts a werewolf attack.

The transforming werewolf

This is a slightly more advanced project than the Shape-shifter (see pages 126-9), depicting a werewolf transforming from man to wolf, and takes the form of a multiple-figure illustration.

Step 1: Work up your sketch—the idea here is that the man is in pain, then lurches back into a full werewolf.

Step 2: Transfer the sketch onto 9 x 12-inch 3-ply Bristol board using a lightbox. Use a pencil to work in the details and tighten the sketch up. The important elements here are the strain on the face of the first figure, and the rage on the face of the third figure, so pay special attention to those details.

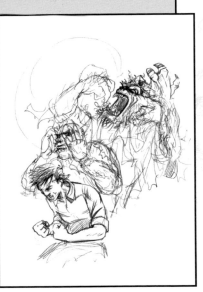

NOTE

Because we want it to appear that this figure is transforming, it's important to have the two figures on the same axis. The red lines show how each of these figures shares the same base as they tilt backward.

Step 3: With the pencil lines down, work in the inking details with a size 2 brush and black ink. While it's usually best to fill in the large dark areas with ink first, in this case getting the third figure's face right is more important, so start there.

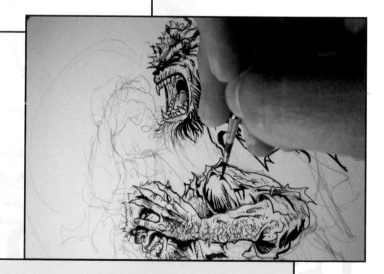

Step 4: Next, begin working in the other shadow areas of the illustration. The size 2 brush will give a rich, fluid line, but you can use a fineline pen for tiny details.

Step 5: Once the inking is finished, scan the dry drawing into Photoshop, where you will do some basic coloring and use two effects.

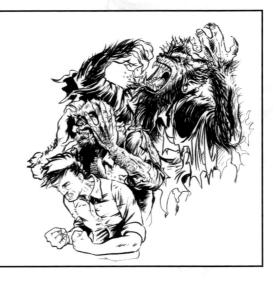

NOTE

Techniques for working in Photoshop are covered in detail on pages 74–87.

Step 6: Add a layer (Layer>New Layer) for color work, then change its option from Normal to Multiply. Using a basic color scheme, fill in all of the illustration.

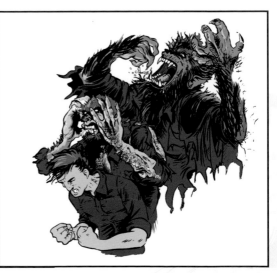

Step 7: Add another layer, choose a warm gray color, and paint in some heavy shadows over the color layer.

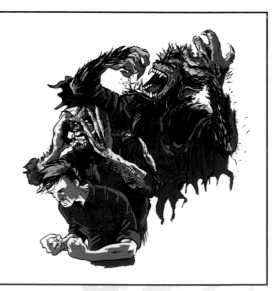

Step 8: Now reduce the Opacity to 85% on the gray layer and change the layer option from Normal to Multiply. The gray will now act as a shadow.

Step 9: As a special effect, add a plaid pattern to the werewolf's shirt—it seems that plaid is popular among werewolves. Either find a plaid pattern online or scan one in.

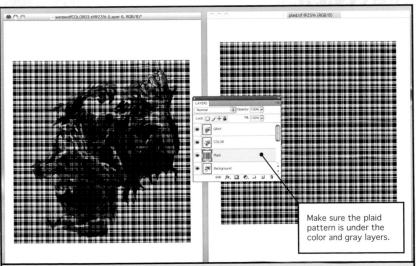

Make sure the plaid pattern is under the color and gray layers.

Step 10: With the two windows open, drag the plaid pattern over onto the werewolf illustration, making sure it is on a new layer beneath both the color and gray layers.

Step 11: Now go to the color layer and use the Magic Wand to select the shirt color. Go to Select> Similar, and all of the colors for the shirt will now be selected, indicated by marching ants. Go to Select>Inverse and go to the layer with the plaid pattern on it.

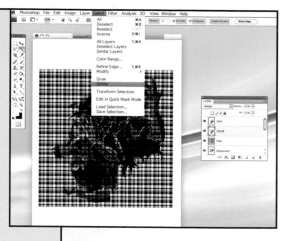

Step 12: Hit the Delete key and you'll now have a plaid pattern over all of your shirt areas. Take the plaid layer and reduce the Opacity to 46%. Change the layer to Multiply and the pattern will fade into the color and give a more subtle effect.

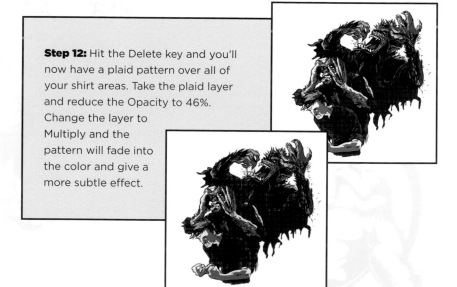

Step 13: The illustration is coming together, but needs a moon. Do a Web search for a moon, then bring that into your illustration. Alter the Hue/Saturation or paint it with a orange color and change the Opacity to Multiply. Finally, erase the portions of the moon that overlap the werewolf.

CHAPTER 5

VAMPIRES

Among the most popular supernatural beings, vampires can be scary, evil creatures or enticing, sensual beings. The real spine-chilling aspect of vampires is that they are so close to humans in form, so the artist can afford to be creative with skin tones and the focus of the eyes.

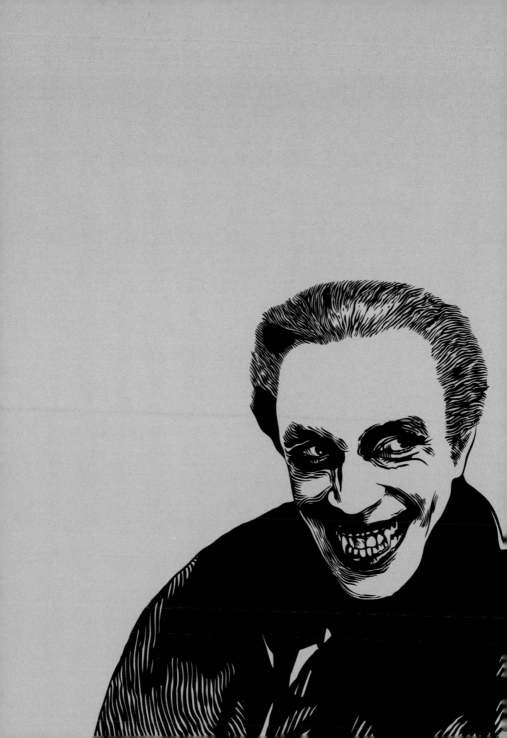

VAMPIRES

O f all the supernatural beings the vampire might be king. In recent times vampires have become synonymous with angst-ridden teenagers, thanks to contemporary books and movies, but the original concept of the vampire is of a much more frightening creature of the night. Thought to be undead, the vampire is a soulless phantom who is forced to drink the blood of other humans in order to carry on, and must return to its grave each night before sunset.

Vampires were once the stuff of legend, but entered popular culture with *Varney the Vampire*, a serialized gothic horror story by James Malcom Rymer that first appeared in the "penny dreadfuls"—cheaply produced pamphlet-style magazines that were extremely popular with an entertainment-hungry Victorian audience. Bram Stoker cemented the vampire's role in popular fiction with his 1897 classic novel *Dracula*. Stoker described Dracula as an aristocratic-looking older gentleman with a broad mustache and sharp pointy teeth. The new medium of film was quick to adapt the book, with 1922's German expressionist film *Nosferatu* being the most successful. The vampire in the movie—whose name was changed from Dracula to Orlock due to copyright issues—was depicted as a rat-like creature, a symbol of the bubonic plague.

Right The cover image from one of the original *Varney the Vampire* publications, circa 1845.

In 1927, MGM Studios released *London After Midnight*, which featured their reigning king of suspense films Lon Chaney as a possible vampire, in makeup that was considered quite startling for the time. When Bram Stoker's book was adapted for the London stage, the producers opted to present Dracula as a formally attired, darkly handsome count from Transylvania. When Universal adapted the play to film they cast Hungarian Bela Lugosi, who was then performing the role on Broadway.

Count Orlock
Max Schreck as Count Orlock in the 1922 classic vampire movie, *Nosferatu*.

Vampiric character
Lon Chaney's makeup was startling in the, now lost, vampire-style movie *London After Midnight*.

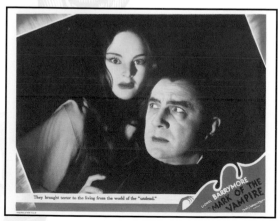

They brought terror to the living from the world of the "undead."

Movie vampire
As well as playing Dracula in 1931 for Universal, in 1935 Bela Lugosi appeared again as a vampire in *Mark Of The Vampire*.

Male vampire

This illustration combines two classic vampire elements: the rat-like look of Nosferatu and the aristocratic styling of Dracula.

Step 1: Work up some sketches for your vampire pose—it's always good to try a few options. This one with the skull was chosen for its feeling of energy.

Step 2: Use a lightbox to transfer the sketch onto 3-ply Bristol board and work in the details in pencil. Indicate where the black areas in the illustration will be.

Step 3: To fill in the blacks use brushes and black ink. Use a small, size 2 brush for detail areas, and a larger brush for bigger areas.

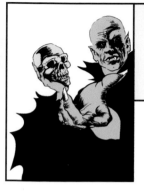

Step 4: Use colored inks to fill in a base of color. Remember that working with a clean and reasonably dry brush will keep your colors smooth.

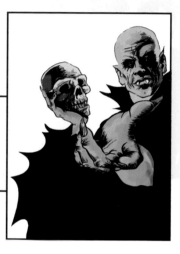

Step 5: Let the base dry thoroughly, then work in some form color using gouache paints.

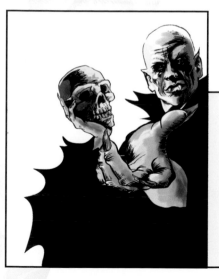

Step 6: Mix in some white paint with a little green to lighten up the vampire's face. Use a small amount of water to achieve a milky wash effect that gives the skin a creepy pallor.

Female vampire BY VERONICA FISH

An illustration of a female vampire can be sultry and alluring. This vampire project focuses on a red-headed creature, and is a great lession in skin tone and final touches.

Step 1: Draw the image out in graphite, scan it, and open it in Photoshop. Do not worry about the unfinished aspects, you'll be improving the piece as you go.

Step 2: Add a new layer and set it to Multiply to allow the pencil underneath to show through. Define each piece with a consistent color palette. To give depth, darken background to a navy/gray and the skin to blue ash. The tones are a careful balance. If they become too green, the colors look like Christmas colors, and if they become too green it doesn't feel as rich.

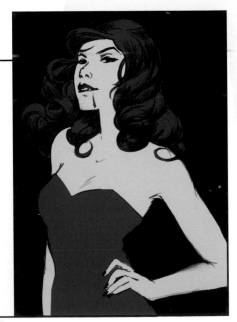

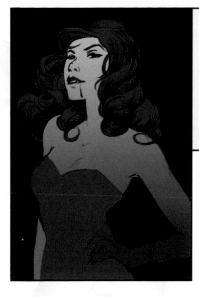

Step 3: Making another new layer, add a red gradient from the bottom up and using the layers menu set it to Darken, using the Gradient tool from the tool bar. This gives a cool, creepy atmosphere.

NOTE

Note that the female figure has a higher-set waist and wider hips than you would see with a male figure.

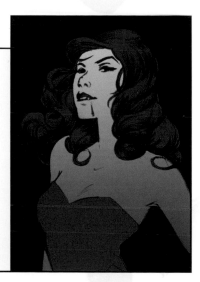

Step 4: Add a new layer and select from the crown to about the shoulders using the Lasso selection tool. Then using the Gradient tool, drag the dark blue from the head down, and in layers menu, change the setting from "Normal" to "Lighten." This causes more saturated tones and highlights to come out and add to the red/blue/orange spectrum.

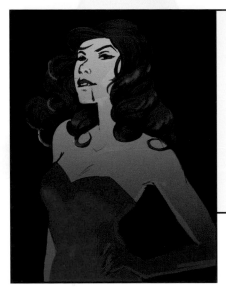

Step 5: Set the pen tool to Color Dodge and add low lights using a Soft Brush. Imagine there is a lamp underneath the vampire's face and choose areas which would be bathed in color from this angle for low lights. This creates a life-like glow effect, and accentuates the drama.

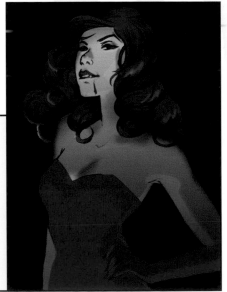

Step 6: Shadows are added using a larger, softer brush and setting the pen tool to Color Burn. The contrast is starting to give her dimension—use the Smudge tool to smooth out any rough lines and tweak the anatomy.

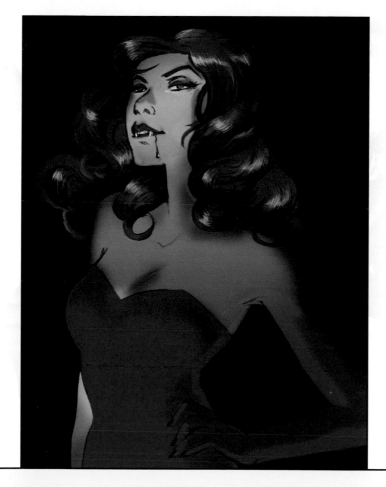

Step 7: The overall image is touched up and tightened. The hair needs some bright orange highlights with a tiny Brush, all the edges of the body are improved to better meet with the dark background, and the eyes and teeth have some finer details added. Select the background with the Wand tool, and add a Noise Filter, to give the background a little something extra.

Pisacha BY SERJ PALIHOUICZ

Pisacha are evil flesh-eating entities originating from Hindu folklore. They are know for their hideous looks and savage attitude, but since the character in question is female I aimed to strike a balance between a feminine beauty and a monstrosity. This project helps you work with color and light.

Step 1: With a medium-sized Soft Round brush, start a rough sketch in Photoshop. Try to concentrate on the general shapes and character pose. This sketch will be used later as a reference.

Step 2: From Image Adjustments, select Levels and change the Output Levels to 150; this should make the lines just barely visible. Create a new layer and with a small Solid Round brush start tracing over the existing sketch, while adding details and accentuating the shape of the character.

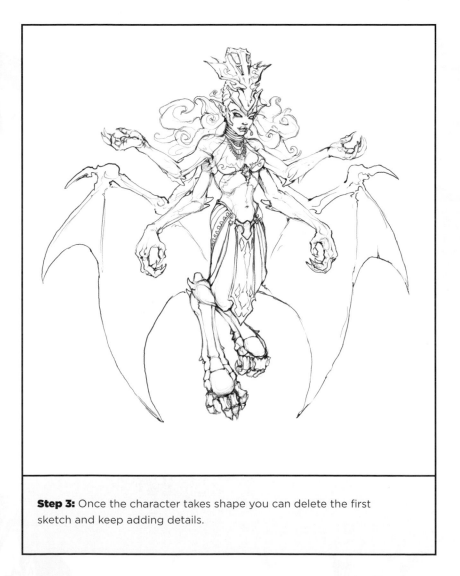

Step 3: Once the character takes shape you can delete the first sketch and keep adding details.

Step 4: Create a new layer underneath the existing sketch. With a medium-sized Solid Round brush start applying a gray undercoat to the character. Make sure to use a medium shade of gray; the underlines should still be visible.

Step 5: Create the third layer on top of the previous two. Pick a darker gray color and start applying the shadows. You can switch between Soft and Solid brushes to give the shadows a more believable appearance.

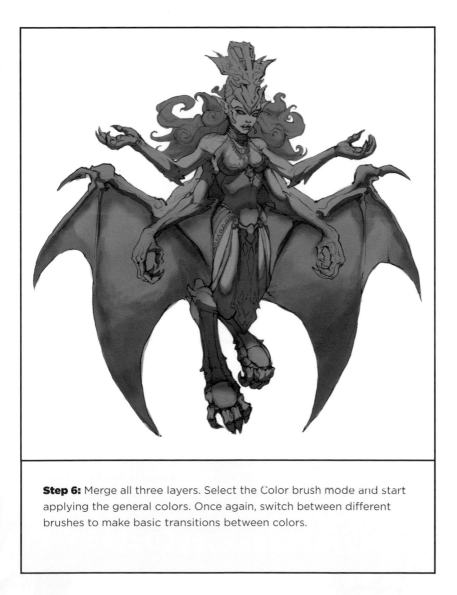

Step 6: Merge all three layers. Select the Color brush mode and start applying the general colors. Once again, switch between different brushes to make basic transitions between colors.

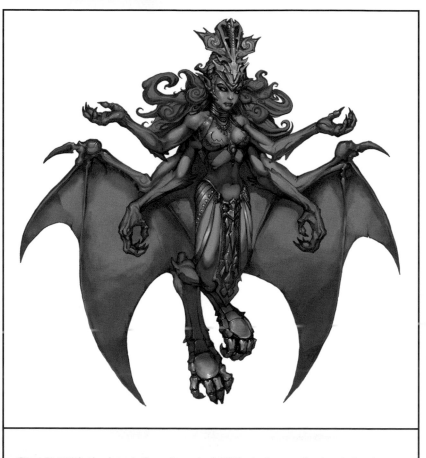

Step 7: With the brush Opacity set at 60% start rounding and shaping the character, adding shadows where needed. Now use the Dodge tool on the clothes and headdress to achieve a shiny look, taking care not to overdo it.

Step 8: In Blending Options, select Gradient Overlay. Set Blend Mode to Linear Burn and Opacity at 30%. Select a cherry red and a bright yellow. Set the brush to Color mode, select a dark green, and apply a few spots to the headdress to achieve a bronze effect. Use the Dodge tool on the hair to get a glowing effect.

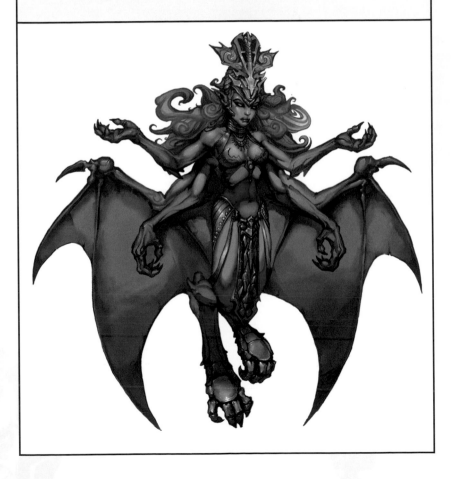

CHAPTER 6

VOODOO PRIESTS AND ZOMBIES

When it comes to creepiness, it's hard to beat voodoo high priests and zombies—they go together like peanut butter and jelly!

VOODOO AND ZOMBIES

Baron Samedi might be a sinister creature, but he needs a zombie army to command. Many cultures still believe in zombies, and since the 1930s Hollywood has added to the zombie legend, first in a more traditional styling of the mindless Haitian creature lumbering to its intended destination under the spell of voodoo. When George Romero released *Night Of The Living Dead* in 1968 the perception of the zombie changed to a reanimated corpse wandering the streets (and sometimes malls) looking to eat the brains of the living.

Walking corpses
George Romero's movie *Night Of The Living Dead* frightened a whole new generation of horror and supernatural fans.

Zombie

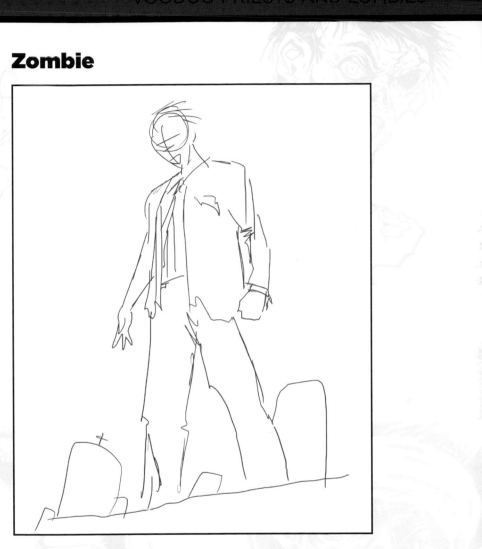

The zombie project over the next six pages is different from
many of the others in this book because the camera angle is set
lower, so the viewer looks up at the zombie.

Using camera shots as inspiration

Medium shot

Full shot

Bird's eye view

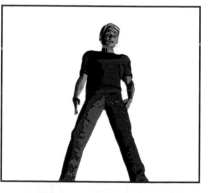

Worm's eye view

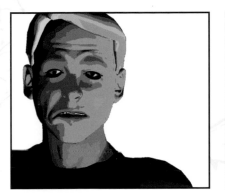

Close-up

Long shot

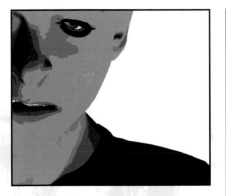

Extreme close-up

NOTE

Like a film director, an illustrator has to consider the dramatic effect of the point of view of the composition. By varying your "camera shot" you change the perception and mood of your piece. You can combine shots, too, so it's possible to have an extreme close-up/worm's-eye view to add to the drama.

Step 1: Make a preliminary sketch and transfer it to 3-ply Bristol board, using a lightbox if you like. Because this is a piece with a lot of detail in the face, try working on 11 x 17-inch Bristol board. Start working in the details. At this early stage, think about the light source and where shadows are going to fall.

NOTE

To give the illusion of depth, note the arching form that indicates the shape of the chest, as well as the horizontal form making up the top of the pants. The slight angle on the belt line makes it clear that this figure has form.

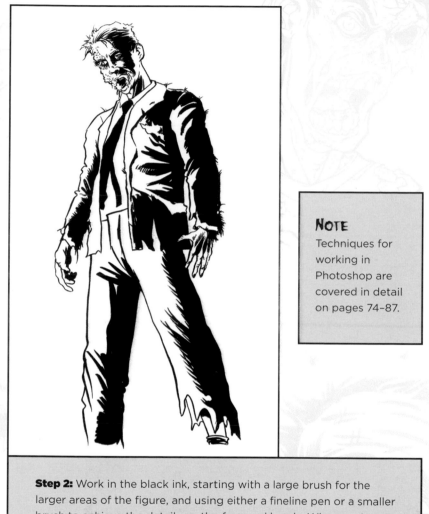

NOTE
Techniques for working in Photoshop are covered in detail on pages 74–87.

Step 2: Work in the black ink, starting with a large brush for the larger areas of the figure, and using either a fineline pen or a smaller brush to achieve the details on the face and hands. When you've finished adding the black ink, let the piece dry, erase all the pencil lines, and scan it into Photoshop to color.

Step 3: Add a layer (Layer>New Layer) set to Multiply and paint in all the base colors. Don't worry about form yet, just fill the color in flat.

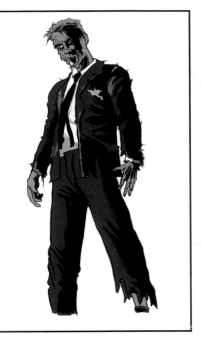

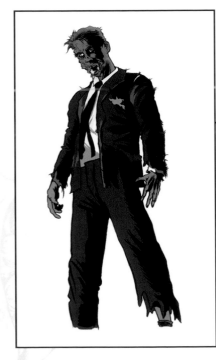

Step 4: Add another layer set to Multiply and work in some shadows to emphasize the form of the figure.

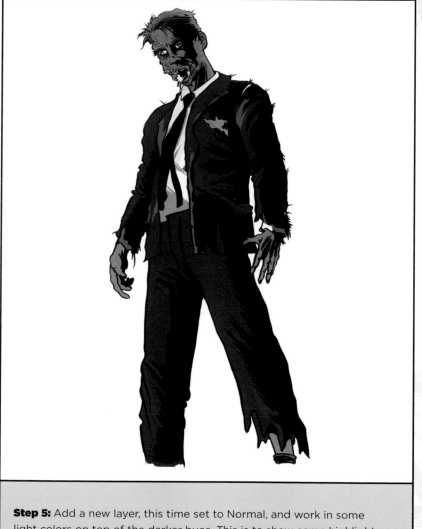

Step 5: Add a new layer, this time set to Normal, and work in some light colors on top of the darker hues. This is to show some highlights on the figure.

Baron Samedi

Perhaps the king of all the voodoo high priests is Baron Samedi. The baron is a master of mayhem, usually depicted wearing a top hat and black tuxedo, and with either a skull-painted face or an actual skull for a face. The baron is perhaps most famous as a villain in the James Bond movie *Live And Let Die* (1973).

TIP

Mood is as important as the design of the character. Heavy black shadows and a creepy lurching pose add to the overall feel of the illustration.

Step 1: Work up a preliminary sketch, bearing in mind that the pose and cane are going to be the focal points of this piece.

Step 2: Transfer the loose sketch to 3-ply Bristol board, using a lightbox if you like, and use a mechanical pencil to work in the details.

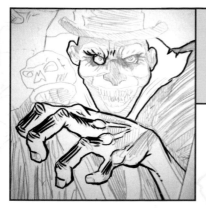

Step 3: Once the pencil lines are all down, begin inking the drawing, using either brush pens or a brush and black ink.

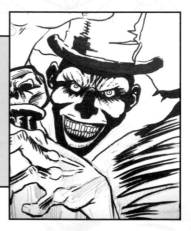

Step 4: The skull pattern on the face is very important here, since that and the top hat are the baron's most identifiable attributes. Opting to go with a human face painted like a skull is countered by the skull topper to his cane.

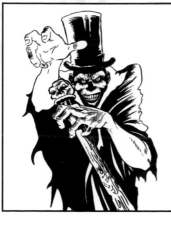

Step 5: Finish up the ink drawing with large black areas and some creative shadowing. Scan the image into Photoshop and add a layer (Layer>New Layer).

Step 6: Zoom in on the face area (View>Zoom In). Choose a size 9 Round Brush and black from the Color Picker and, on the new layer, add in some subtle line work around the eyes and brows. This gives the figure more "attitude."

NOTE

Techniques for working in Photoshop are covered in detail on pages 74-87.

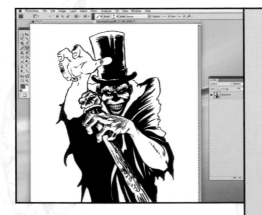

Step 7: Go to Layer> Flatten Image to make the image a single layer. You'll see the image is now shown as one layer on the Layers palette. Choose the Magic Wand tool and select the white areas around the figure— you'll see the marching ants wherever you select.

TIP

When using the Magic Wand, if any of your Samedi figure gets selected by mistake, you will need to use a small brush, such as a size 3, to close up any spaces left open in the ink drawing. Go to Select>Deselect to remove the marching ants and use the small brush to close up the open lines. Once these lines are closed up you can go back and choose the area around your figure again, without touching the figure itself.

Gaps are now closed.

Step 8: With this area selected, add a new layer. Change this layer to Multiply, then go to the Color Picker and choose a medium gray color. Now go to the Brush tool and select a 59 Splatter brush, but move the Diameter bar over to select a brush size over 1,200 px.

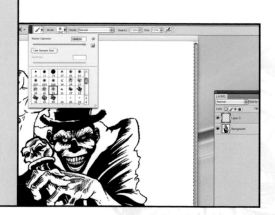

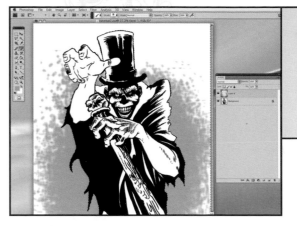

Step 9: With this huge brush, work in some color around the figure on the new layer.

Step 10: Add another layer, also set to Multiply, and select a darker gray with the Color Picker. Go to the Brush tool and make your brush a little smaller, about 700 px. Now draw in some color on top of the gray you've already done—since it's set to Multiply the darker shade shows through.

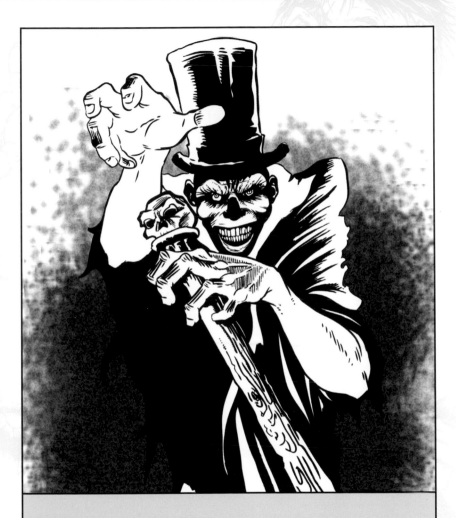

Step 11: Making sure you're on the upper gray layer, go to Layer>Merge Down. Now both gray layers are combined. Go to Filter>Artistic>Sponge to create an interesting texture over the gray area.

CHAPTER 7
LEGENDARY
HUMANOIDS

From the bogeyman to the Yeti, we have long
been preoccupied with hairy humanoids and
beast-like bodies.

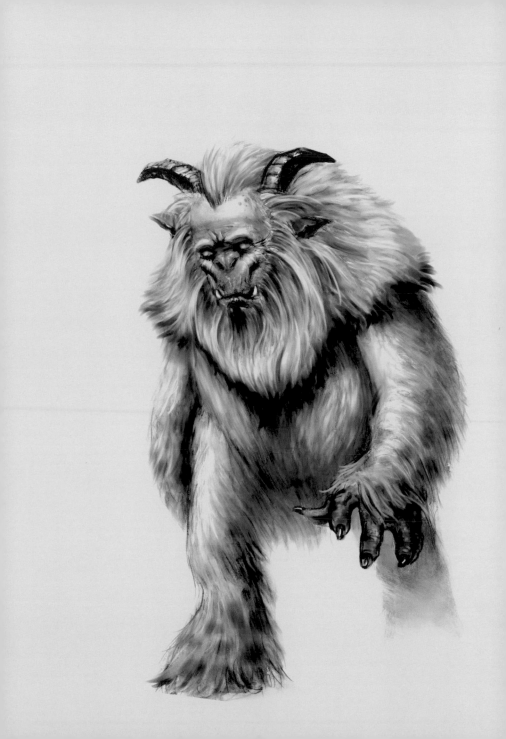

Bigfoot BY SCOTT ALTMANN

A character from folklore, Bigfoot is a forest-dwelling ape-like animal whose existence has never been proven. This project will focus on creating the creature, concentrating on bringing out its feral and animal characteristics rather than its human similarities. It is a great beginner project for illustrating short hair on a muscular body.

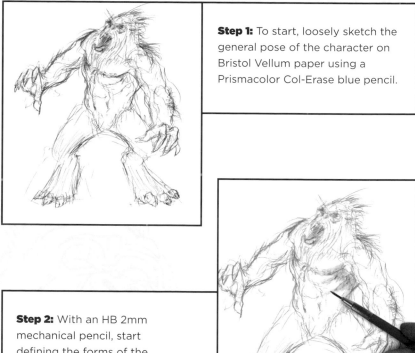

Step 1: To start, loosely sketch the general pose of the character on Bristol Vellum paper using a Prismacolor Col-Erase blue pencil.

Step 2: With an HB 2mm mechanical pencil, start defining the forms of the creature by lightly adding in values. Keep the drawing loose by using the side of the pencil.

Step 3: Next, use very dilute acrylic paint and apply a thin wash of raw umber, raw sienna, and manganese blue over the entire drawing, using a large mop brush.

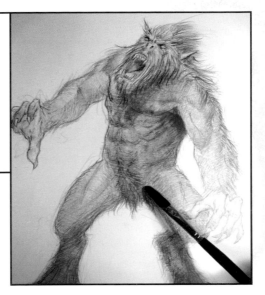

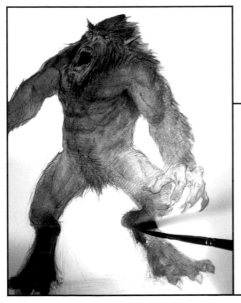

Step 4: To achieve a greater range of values, apply several thin washes over the drawing. Each layer darkens the image a bit more. Work quickly and loosely, to allow the natural qualities of the traditional media to show once you begin to work digitally.

Step 5: Using a size 0 round brush, add a bit more definition to the shadow areas. This character has short hair, but you can give the picture more life by introducing some areas with hair of varying length. The small brush is good for adding these details.

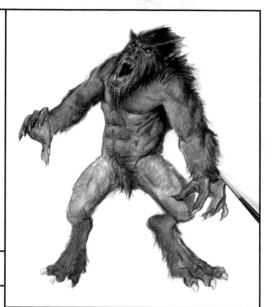

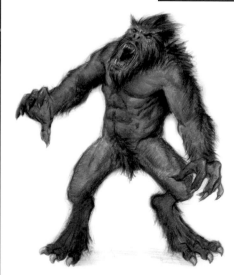

Step 6: Scan the Bigfoot image at 300 dpi. Once in Photoshop, clean up the edges and perimeter of the creature. Use a Round brush and, with the background white color, begin refining the overall shape.

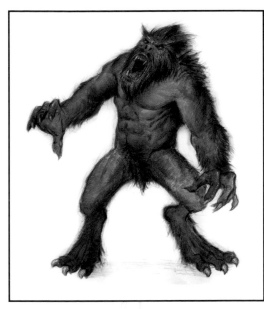

Step 7: Create a new Overlay layer in the Layers palette. Using a large Soft Round brush add some warmer orange and maroon hues to the fur, while leaving some areas untouched. This creates more variety in the texture and color of the fur.

Step 8: On a new Normal layer, choose a very small Round brush and start working on the fur, paying close attention to the form of the creature. Having the brush strokes follow the form of the creature enhances the dimensionality of the image. Add more details to the face; the strokes of fur and definition around the mouth.

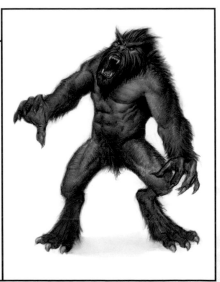

Step 9: Add another Overlay layer and paint a warm sienna tone over the entire image. This gives the image a warmer appearance and also helps unify the several different hues on the Bigfoot's fur.

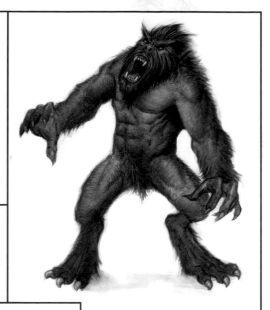

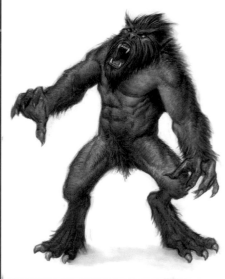

Step 10: Create another Normal layer and start any last refinements. Add some lighter values to the legs of the creature, to give them more life. Using a tiny Round brush, paint in a few stray hairs in random spots.

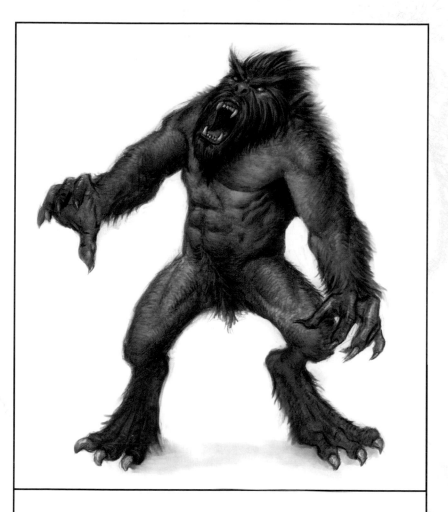

Step 11: Add one more Overlay layer to enhance the color quality, using a Square, Natural Media Chalk brush, and add some purples into certain areas of the fur. With a nice balance of warm tones and neutral tones achieved in the image, it is now finished.

Yeti by Scott Altmann

The Yeti is an ape-like creature said to inhabit the Himalayan region of Nepal and Tibet, where it is part of native legend. This project will focus on creating an illustration of the creature, showing you how to draw realistic long hair using pencil and paint techniques. It depicts him with horns to differentiate him from his Bigfoot cousin.

Step 1: Using a blue Prismacolor Col-Erase pencil, loosely sketch the general construction of the Yeti. The surface is Bristol Vellum paper. There is almost no detail at all, and only slight indications of light and shade.

Step 2: Switch to a 2mm mechanical pencil, using an HB lead. Use the side of the pencil to make broad strokes and to keep the drawing loose.

Step 3: Switch to a smaller mechanical pencil, using a 0.5mm 2B lead in order to achieve more detail, and get the shadows darker. Since the Yeti is covered in fur, the mechanical pencil is perfect for rendering strokes of hair.

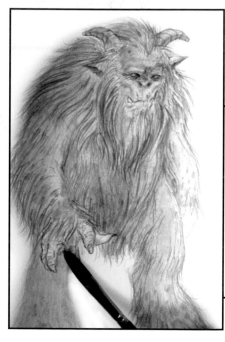

Step 4: Using acrylics, dilute manganese blue with a dab of raw umber for the fur. For the face and hands, use a watery yellow ocher and quinicridone red. Using a no. 8 mop brush, cover the entire drawing with the acrylic wash.

Step 5: For this step use a synthetic sable filbert, size no. 4, using the same colors, but now adding titanium white for the lighter parts and a bit of cerulean blue to add variation to the cool hues.

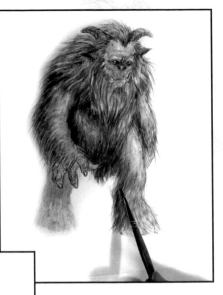

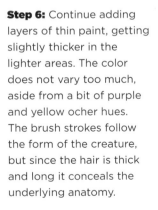

Step 6: Continue adding layers of thin paint, getting slightly thicker in the lighter areas. The color does not vary too much, aside from a bit of purple and yellow ocher hues. The brush strokes follow the form of the creature, but since the hair is thick and long it conceals the underlying anatomy.

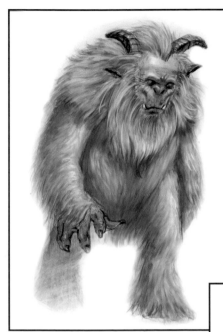

Step 7: Scan the image at 300 dpi. Then open the image in Photoshop and, using the Smudge tool, begin softening the fur; leave only a few spots of fur not smoothed out. With the Round brush, start to render the face of Yeti. Using the Color Picker, use colors already established in the traditional painting.

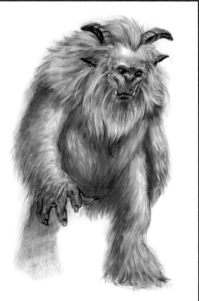

Step 8: Create a new layer and set it to Overlay. Using a large Soft Round brush, enhance the blues by adding a mix of cool greens and blues on top.

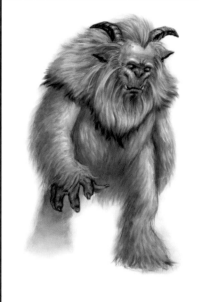

Step 9: At this stage, start adding more detail work. Reduce the size of brush, and, on a Normal layer, begin refining the face. Add a bit more warmth to the nose to provides a good contrast against all the cool hues in the fur. Begin adding some darker accents to the tips of some fur on the Yeti's upper body to break up the overall shapes.

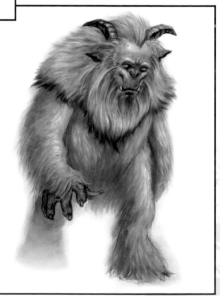

Step 10: The blues are a bit too strong here. In order to achieve an overall cool appearance to the Yeti, create an Adjustment layer in the Layers palette and select Color Balance. In the Midtones section, reduce the amount of cyan by a fraction.

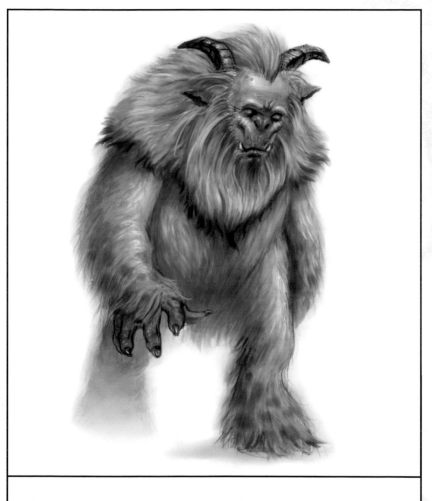

Step 11: Give the fur some spots, but only in a few select areas. Create a Multiply layer and paint a few a spots of varying size and shape onto the fur. Reduce the opacity to 45%, add a subtle shadow, and the creature is complete!

CHAPTER 8

MYTHICAL CREATURES

The supernatural world doesn't have to be frightening. This section covers the most beautiful and ethereal creatures in the artistic world, for those of a lighter temperament.

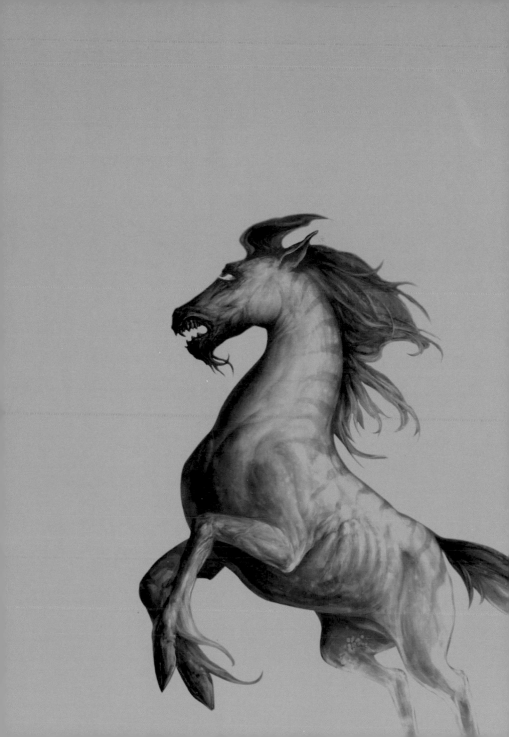

Fairy BY MICHELE CHANG

This project will focus on creating a traditional-style fairy character, rendered to resemble illustrations of fairies commonly found in fairy stories. It will help you become aware of lighting techniques and choosing a light source.

Step 1: Start by using very simple lines to capture the gesture of the character's pose. This fairy is striking a playful pose. Here, the light source will be the round object on the stick she's holding. This will help make lighting straightforward and easier to visualize.

Step 2: Preliminary details are sketched in. The overall silhouette is defined at this stage and any tangents in the pose should be corrected to make sure all the overlapping parts of the character are easy to read at a glance.

Step 3: Fairies are woodland creatures with elements of insects and plants. To illustrate this, antennae are added above her eyes. Her wings combine the design of insect wings with leaf structures.

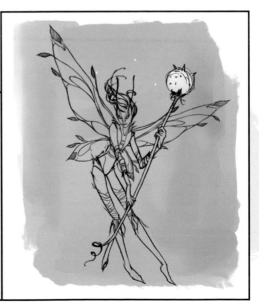

Step 4: With a broad brush, paint a thin layer of color over your sketch to find a value for the ambient lighting. The glowing orb at the end of the stick she's holding will be the brightest area of the entire illustration, hence it is left unpainted.

Step 5: Use a medium-sized brush to paint in her colors in flat values, as if the only light source were the dim ambient background color. Earthy colors are used to emphasize her woodland-creature attributes. Your paint strokes should be thick enough to cover the line art underneath.

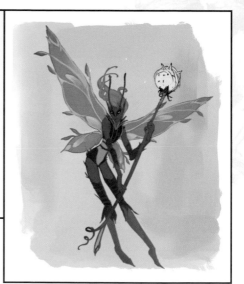

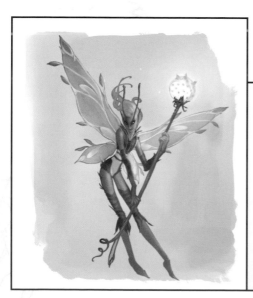

Step 6: The plant orb is rendered in very bright greens to give it a soft glow. Referencing this light source, start painting a new thin layer of brighter greenish-gold highlights over the base color you established on the fairy in Step 5.

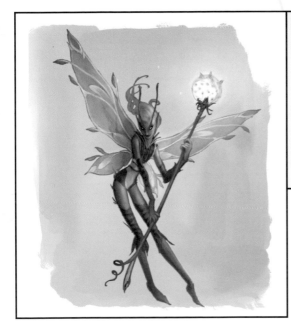

Step 7: Using a thin layer of unsaturated dark brown, start shading all the areas of the fairy where the shadows are deepest and most obscured from the light source.

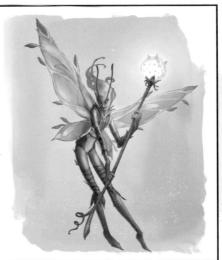

Step 8: Pick a pale pink color and add another thin layer of highlights to all the areas that are most brightly lit by the orb. Pale pink contrasts with the earthy colors to give a surreal gloss to her hair, skin, and clothes. Paint in the pale green shades of her background into the parts of her wings that are most translucent.

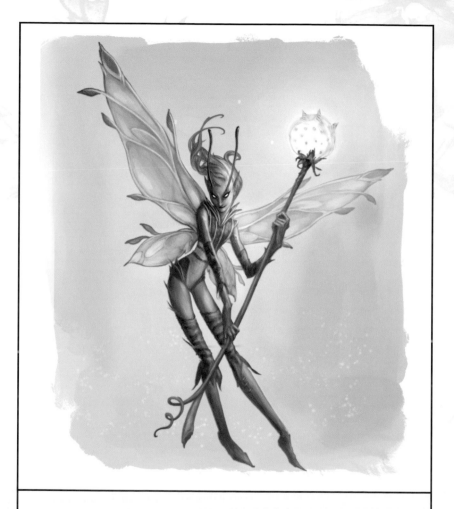

Step 9: More details are rendered with a fine-tip brush, adding more shadows and highlights according to the direction of the light source. As with the previous step, dark browns are used for shadows and pale pinks are used for highlights.

Step 10: This is a reiteration of the previous step, where final detailing is achieved through adding more shadows and highlights, resulting in the character looking solid, with a more interesting range of contrast.

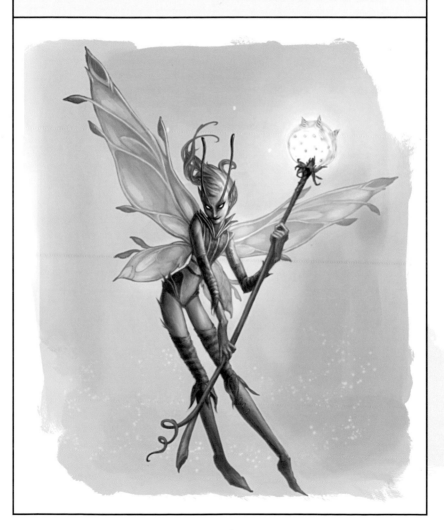

Kelpie BY MICHELE CHANG

The Kelpie is a supernatural shape-shifting water horse from Celtic folklore. This project will focus on creating such a creature while teaching basic techniques for illustrating water effects.

Step 1: Draw the flow of the ocean waves and the pose of the Kelpie, to establish a strong visual connection between the creature and its element. The shape of the Kelpie's pose thus looks very close to a double cresting wave: the main arch being its body, and the secondary arch its neck and head. The Kelpie is malevolent, so the environment should echo its nature.

Step 2: Start detailing the Kelpie's anatomy. This is a supernatural water creature, and its appearance will need to be clearly different from a horse. Carnivorous teeth, cloven and tapered hooves, aquatic stripes, blazing white eyes, a goatee, and slightly abnormal body measurements achieves this look while retaining the horse-like character.

Step 3: Use a broad brush and paint a thin layer of unsaturated blue and pale orange to define the horizon and the sky. Blue and pale orange are two colors that will contrast well to set the mood for an overcast dawn sky.

Step 4: The main light source puts most of the head and chest in shadow. Add light to the area where its hind legs are in contact with the water. Pale unsaturated purple is used to contrast with the pale orange background light. Paint in all colors, shadows, and highlights with a medium-broad brush.

Step 5: The wave sections are rendered in low-opacity light blue strokes that follow the movement of the waves. The skin of the Kelpie itself is painted with variable hues of purple, blue, light yellow, and light brown to make it look glossy and cold, as if it were made of fluid ice, to enforce the water element.

Step 6: A new layer of bright blue is added wherever the light hits the most. The Kelpie's hind legs are outlined in bright blue and inner body masses are shaded darker to make it look semi-transparent and watery. My intention is to make the Kelpie appear to be solidifying as it leaps out of the water, so its hind legs are still partially transformed during the process.

Step 7: More anatomy details are added to the Kelpie's upper body. This is painted with soft brush strokes of transparent blues and whites. Only the brightest highlights and the darkest shadows are painted with hard-edged brush strokes.

Step 8: A pale greenish hue is added to highlights, simulating a slight refraction of ambient lighting from the sky. The Kelpie's anatomy is still being defined and adjusted.

Step 9: More lighting adjustments are made to get the right mood. Aquatic stripes are painted over the Kelpie's neck and back once all the basic skin details are done.

Step 10: Finally, paint in watery foam by dabbing a round-tipped brush with a white on low opacity. Use a fine-tip brush to outline highlights on all the splashing water. Only foam the edges of the waves and add a spray of water droplets where the edges meet.

CHAPTER 9

SETTINGS AND ENVIRONMENTS

Once you've mastered the art of supernatural beings, it's time to place them in their natural environments.

Zombie setting

This project adds a setting to the Zombie project from pages 157–63. In this case the drawing starts out as little more than a character design, but it can be made more interesting by adding a few props.

Step 1: Open the zombie illustration, duplicate the layer (Layer>Duplicate Layer), then use the Magic Wand tool to select the area around the figure. Press Delete on the keyboard to get rid of the white. Add a layer underneath the zombie copy and fill it with red using the Paint Bucket tool.

NOTE
Techniques for working in Photoshop are covered in detail on pages 74–87.

Step 2: Add a new layer (Layer>New Layer) and draw in the ground and the shape of a tombstone in the foreground in front of the zombie. Click on the layer with the red color, then add another layer. On this layer draw in the shape of two tombstones, this time in a medium-gray color.

Step 3: While still on the gray tombstone layer, go to Edit>Transform>Perspective. Your two tombstones will be selected by a bounding box. Grab one of the squares on the left of the box and push it down, and the tombstones will change shape. Grab the middle-left square and pull it down to pull the tombstones down so that they look as if they are receding into the distance.

Step 4: Go To Edit>Transform>Skew to tilt the tombstones over to the right. To eliminate the part that covers the zombie's leg, go to the black-and-white drawing layer and click on the pant leg with the Magic Wand tool. Go back to the gray tombstone layer and press Delete on the keyboard. Now the black of the figure's pant leg shows through the tombstone. Go to Select>Deselect to remove the selection lines.

Step 5: Use your Polygonal Lasso tool to create the side shape of your background tombstone. Add a layer and click inside the marching ants to fill this area with paint. Do the same thing with the other tombstone in the background.

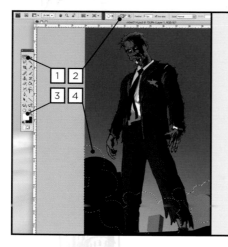

Step 6: Add a layer and select the Elliptical Marquee tool (1). Choose the Add to selection option at the top of the screen (2)—this will allow us to group our balloon shapes together. Use your Color Picker to choose white paint (3) and then move back to your Elliptical Marquee tool to draw a series of circles at the bottom of your zombie illustration (4).

Step 7: Use your Paint Bucket tool (1) to fill the circles you've just drawn with white paint (2) remembering to keep it on a separate layer (3).

Step 8: Let's add an outer glow on the outside of the white circles. Go to Layer> Layer Style> Outerglow. Use the slidebar to adjust the options on the Outerglow so that the edges of the circles you've just drawn become soft and cloudlike. Set the Blend Mode to "Screen" and bring the Opacity up to 100%. Now in the layer options reduce the layer Opacity down to 70%—this will give you a more fog-like look to the clouds.

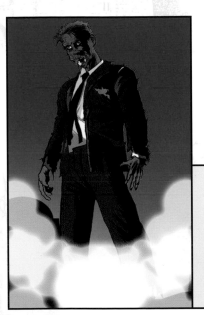

Step 9: Now go to the layer you've added the fog to and go to Layer>Duplicate layer—then go to Layer>Transform>Flip horizontal, Repeat and use your Move tool to push this layer of fog downward to achieve a cascading billow of fog.

Goblin setting

This more advanced piece of scenery gives the goblin from pages 90–3 some atmosphere.

Step 1: Source photographs of forest scenes to use as reference material, and pick out details that can be used in the illustration.

NOTE

When using photographs within your work, ensure they are copyright free. If not, you will only be able to use your illustrations for personal use rather than self-promotion.

Step 2: Use the photographs as loose reference, and sketch out a small area of the forest, in this case featuring a fallen log and a lot of trees. Keep the sketch loose. There's also going to be some kind of goblin house (whatever that is) set in the thick trees.

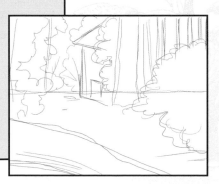

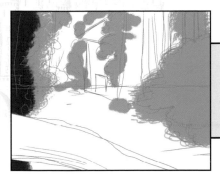

Step 3: Add a new layer (Layer> New Layer) and start working in some colors, beginning with the greens.

Step 4: Fill in the ground color, the sky color, and the color for the fallen tree trunk.

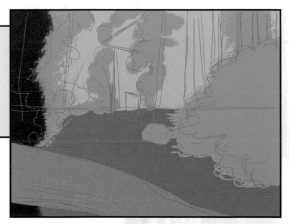

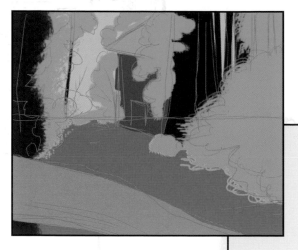

Step 5: Work in the color for some of the trees in the background, as well as the base colors on the goblin house.

Step 6: Work in some detail using a variety of browns chosen with the Color Picker and a 59 Splatter brush resized to about 30 px on the Diameter bar. Vary the pattern and the colors and use a combination of brush strokes, as well as just tapping with the pen on a digital tablet to give a nice mix of shapes.

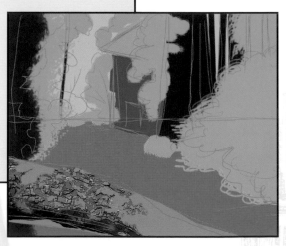

Step 7: Repeat Step 6 with the ground colors, mixing brush sizes and colors.

TIP

A great way to select similar colors when working with the Color Picker is to utilize the Eyedropper tool to select the original color you want to start with. When you select Eyedropper and click on a particular color in the illustration, that original color is now selected in the Color Picker. Move the mouse a little to get a lighter or darker shade of the same color.

Step 8: Continue to experiment with different brush sizes and shades of color. While it might seem like a lot of work to get all this texture in, it actually goes pretty quickly. Just put on some good music and get lost in having fun with a variety of brush strokes.

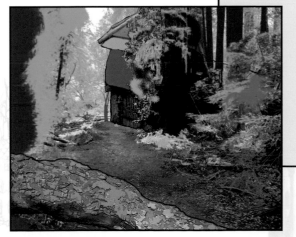

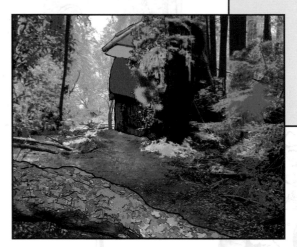

Step 9: Work in leaves and sky in the upper left-hand area; working in really abstract shapes makes it come together quickly.

Step 10: On the goblin house, use shades of blues and grays to give texture to the roof shingles and the stone front.

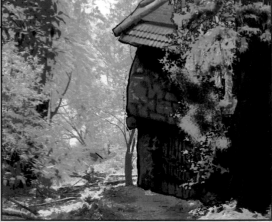

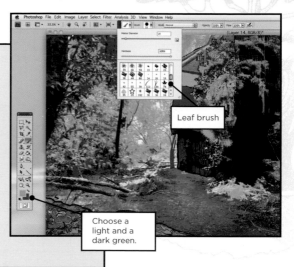

Step 11: Select the Brush tool, which will bring up the Brush Option box. Scroll down and click on the Leaf brush. Choose a light and a dark green on the Color Picker. Add a new layer and try painting with the leaf brush over to the left of the illustration.

Leaf brush

Choose a light and a dark green.

Step 12: Use the Polygonal Lasso tool to select the area where the leaves intersect with the fallen log, so that you get the marching ants, then hit Delete. Now it will look like those leaves are behind the log. Go to Layer>Flatten Image to bring everything into one layer.

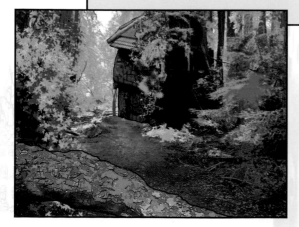

Step 13: Open the goblin illustration and use the Polygonal Lasso tool to select all the white areas around the figure.

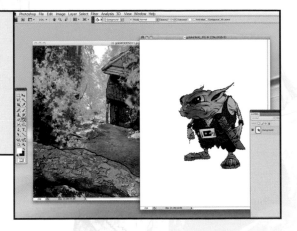

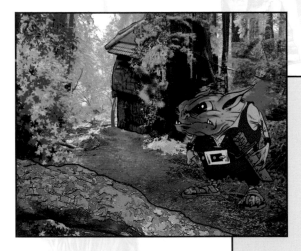

Step 14: Go to Select>Inverse and use the Move tool to drag the goblin on top of the forest drawing. Move the goblin around until you hit on the best position for him.

Step 15: Choose the Burn tool from the Toolbar. This tool allows you to darken just the area you work it on. Move the mouse to the area underneath the goblin and work the Burn tool to create a shadow underneath the creature that makes it look like it actually exists in the woods.

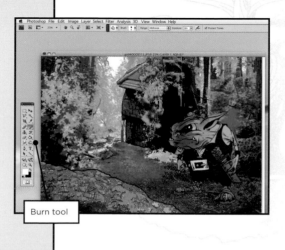

Burn tool

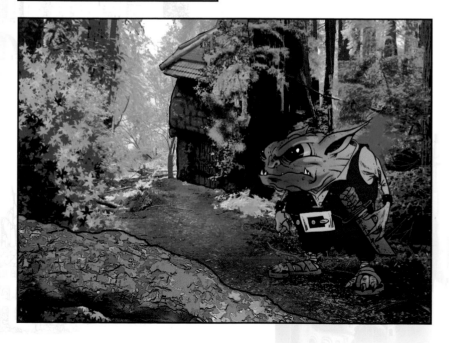

Pixie scene BY EMILIE JENSEN

Pixies are mythical creatures of folklore, usually depicted with pointed ears and often wearing a green outfit and pointed hat. This project will focus on illustrating such a creature within a magical fantasy background.

Step 1: Sketch a rough outline of the main form of the character in the foreground, creating an idea of the midground, and castle and mountains in the background to add depth to the picture. The tree branches act as a frame.

Step 2: Decide where the light source is—the sunset behind the castle—and bring in some shadows. Give the pixie hair, jewelry, and some more features, allowing the character to start to come through.

Step 3: Now start to "clean up" the sketch. I do this by using a lightbox, but if you haven't got one you can use a window. Trace the basic outline onto another sheet of paper, and slowly start to perfect the outline.

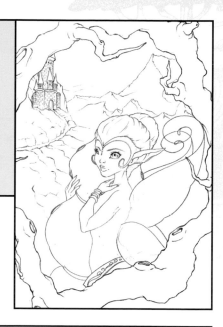

Step 4: Now move onto the coloring, using watercolor pencils. Color the picture by going from dark to light. Put down the main shades with a gray pencil, to get an outline of where you want your shadows to be cast. Use a reference picture when you color in your work, to get an idea of how light naturally falls and creates shadow. Many colors change due to the placement of the sun, for example.

Step 5: Now start to bring in some more colors. When the sun sets it tends to make gray and white shades more pink or purple. To create a cold atmosphere, use purple, gray, and blue tones. Remember that the mountains in the horizon won't show as much detail as the mountains with the castle on them, so ensure they are blurred out the farther away they are.

Step 6: Start to bring in more shading and color, placing some light shades in the foreground. Keep working on the lighting. Create a rim light on the mountains to give the sun a more powerful effect. Give the castle its main shades and put in some vegetation just next to it.

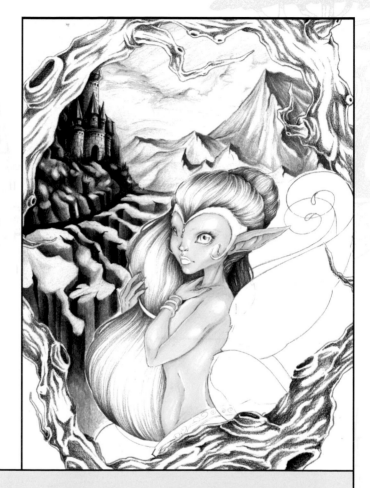

Step 7: Now, give the pixie some color. A second light source for her comes from the right-hand corner instead of the sun in the back, to put her more in focus and so that her hair is shielding her face and body from the sun behind her. Start with a light tone for her skin, which can be built up so that she appears bright, not too dark. Her hair is colored initially with a dark color, to create a deep dark green.

Step 8: Now start to refine the details of the picture. Give the mountains more texture and contrast by using a mechanical graphite pencil, which lets the bottom color shine through and creates a nice crisp shade. Use a gray and a water-green pencil to give the tree a more "mossy" feel. Look up some pictures of trees for color reference if you need to.

Step 9: Fill in the wings with a pink and a yellow tone. To give the wings a transparent feel, keep a light outline of the back wing shining through the front one, and a faint outline of the pixie's back and hair. Using watercolor, wash a blue tone around her and a brown tone around the outside of the trees, to give the picture an old paper feel, as if from an old story book. Use a watery brown tone, let it dry, and then go over it again until the desired finish is achieved.

Glossary

adjustment layers (Photoshop): These work in the same way as transparencies, so you can apply an adjustment (such as hue/saturation changes) on a layer and it will become an adjustment layer. You can create a stack of layers. When you look through the adjustment layer everything seen through it seems to have that adjustment. However, it doesn't actually change the layers below therefore gives you a lot of control over what you do.

afrit: A ghost-like figure made of fire from Arabic mythology.

anime: Short for "animation" in Japanese. Outside Japan, used to refer to Japanese animation.

banshee: A ghost from Celtic folklore, usually a female spirit that lets out a high-pitched shriek to warn of someone's impending death.

composition: The placement or arrangement of visual elements or ingredients in a work of art, as distinct from the subject of a work.

bird's eye view: The focus of your piece viewed from above. Useful for showing a large area or setting the action of your scene.

bristol: A special double-surfaced heavy weight paper used for technical drawing and illustration.

charon: From Greek Mythology, a skeletal figure who leads souls to their death.

complementary colors: Opposite colors that intensify each other when used together.

crosshatching: A clean series of lines crossing over each other—used to create gray tone and give depth and form to your drawings.

dodge and burn tools (Photoshop): The terms "dodge" and "burn" refer to Photoshop digital tools that are used to either lighten (dodge) or darken (burn) specific areas of a work. They are often used to either lighten underexposed areas of a photo or darken overexposed areas.

djinn: A demon in Arab folklore that occupies a parallel world to mankind.

foreshortening: A term used in perspective drawing to suggest that something appears closer to the viewer than it actually is, because of the angle at which it has been drawn.

hatching: A pencil technique that uses lines to create tonal values.

hue: The value of the color of a given object.

intensity: This refers to the amount of a single color in the makeup of another color.

kelpie: A shape-shifting water horse from Celtic folklore.

lasso tool (Photoshop): The Lasso tools are provided in three variations. The Lasso tool and Polygonal Lasso tool which allow you to draw both freehand and straight edge selections, whilst the Magnetic Lasso is ideal for edges set against high contrast backgrounds.

liquid frisket: A substance used in drawing to mask areas of the page that you don't want to ink.

medium shot: Shows characters usually from about mid-thigh up. A good way to establish where your characters are in relation to each other.

perspective: Systems of representation in drawing and painting that create an impression of depth, solidarity, and spatial recession on a flat surface.

pisacha: Evil flesh-eating entities originating from Hindu folklore.

proportions: In art, the size, location, or amount of one part or thing compared to another.

saturation: How much color or ink you use on your page.

temperature: Colors can be warm and cool. Using temperature theory helps you to set the mood.

sasquatch (also known as a yeti): Purportedly an ape-like creature that inhabits forests, mainly in the Pacific Northwest region of North America. Bigfoot is usually described as a large, hairy, bipedal humanoid.

shape-shifting: A common theme in mythology and folklore as well as in science-fiction and fantasy, shape-shifting is when a being has the ability to alter its physical appearance.

sharpen tool (Photoshop): This increases sharpness and contrast in the areas where you paint.

smudge tool (Photoshop): This blends the pixels where you paint simulating the action of dragging a finger through wet paint.

thumbnails: Smaller versions of your pages, useful for preliminary sketches of the novel's events in sequence and useful for organizing content and action, without going into the detail of the finished pages at full size.

tone: The enhancing effect of adding gray to black and white artwork. Used to emphasize form, mood, and shadow.

value: The lightness or darkness of a given color.

wacom: A digital tablet used for drawing on.

About the illustrators

FEATURED ARTISTS

Scott Altmann
www.scottaltmann.com
A professional illustrator from New York, Scott divides his time between illustration commissions and gallery work. Graduating from the School of Visual Arts in Manhattan, New York, Scott pursued illustration and fine art simultaneously. His work has been featured in *Spectrum*, *Society of Illustrators*, *Expose*, *D'artiste/Digital Painting2* and *Exotique*. He is also the recipient of the Chesley Award for Best Cover Illustration: Paperback Books 2009. During the seldom times there is not an art utensil in his hands, he can be found with his wife, son, and cat.

Michele Chang
www.deadred-art.blogspot.com
Michele is a self-taught, acclaimed freelance illustrator. More of her work can be found on her blog.

Emelie Jensen
www.emeliejensen.daportfolio.com
Emelie as been drawing since she was very young, and now works as an illustrator for books and comics.

Serj Palihovicz
Serj graduated art college with a degree in Interior Design and Decorative Arts in 2004. Today he works as a freelance illustrator and aspiring concept artist. The dominant themes in his work tend to be horror, sci-fi, and fantasy, as well as subtle humor.

Peter Tikos
Peter has worked as a freelance illustrator, graphic designer, and concept artist for a variety of worldwide publishing and advertising organizations since 1997. His work has previously been included in "The New Masters of Fantasy" collection. In 2004 and 2005 he was voted among the New Masters of Fantasy artists.

Richard Vass
www.vassrichard.hu
Richard is a member of the Hungarian Comics Academy. His work ranges from creating book covers for fantasy and sci-fi publications and drawings for children's literature to concept design and graphics for computer games. He uses both traditional and digital techniques.

OTHER ARTISTS

Paris Alleyne
www.young-art.devianart.com

Nick Damon
www.ndamon.com
www.artnomad.devianart.com

Eva Kapranos
www.thekarelia.devianart.com

Robin King
www.ripedecay.devianart.com

Robert Triekel
www.thetriekal.devianart.com

Index

Credits

All other images are the copyright of Quintet Publishing Ltd. While every effort has been made to credit contributors, Quintet Publishing would like to apologize if there have been any omissions or errors—and would be pleased to make the appropriate corrections for future editions of the book.

T = top, L = left, C = center, B = bottom, R = right, F = far

ILLUSTRATION CREDITS
Paris Alleyne background illustration 108–23 FR-T.
Scott Altmann 172–7; 178–83.
Michele Chang 186–91; 192–7.
Nick Damon background illustration 6–87 B-R; 172–83 T-L.
Andy Fish 9; 17; 22; 34–5; 38–9, 42–3; 44–5; 48–55; 58–61; 64–8; 72; 71; 92–9; 108–13; 114–17; 126–9; 130–7; 142–3; 157–63; 164–9; 200–11.
Veronica Fish 145–7.
Emily Jensen 212–17.
Eva Kapranos background illustration 6–87 T-L; 126–37 T-C.
Robin King background illustration 6–87 T-L; 108–23 L-C.
Serji Palihovicz 148–53.

Peter Tikos & Richard Vass 2; 11; 100–5; 118–23.
Robert Triekal 107; background illustration 108–23 FR-B.

IMAGE CREDITS
iStock
12; 46 B; 47 T-L, T-R; 89; 155.

www.planetvoodoo.com
156; 163; 169.

New Mexico Energy, Minerals, and Natural Resources Department
70 B-L, B-R.

Shutterstock
10 T; 19; 125; 139.

Other
8 T © Conde Nast Publishing; 8 B © Shigeru Mizuki from the *Yokai Encyclopedia*, 1981; 10 B © Corbis; 13 © Itsnature.org; 73 B © *Encyclopedia Britannica*; 16 © *Punch Magazine*, 1888; 73 T © Gutenberg.org; 140 © *Varney Vampire*, 1845; 141 C © *London After Midnight*, 1927 MGM Studios; 141 B © *Mark of the Vampire*, 1935 MGM Studios; 141 T © Max Schreck; 47 T-R © Wikimedia.